LEARNING
ICT
in the
ARTS

Please check that Computer
Disc/CD-ROM is in book whe
issuing & returning

Other titles in the Teaching ICT through the Primary Curriculum series:

Learning ICT with English

Richard Bennett

1-84312-309-6

Learning ICT in the Humanities

Tony Pickford

1-84312-312-6

Learning ICT with Maths

Richard Bennett

1-84312-310-X

Learning ICT with Science

Andrew Hamill

1-84312-311-8

Progression in Primary ICT

Richard Bennett, Andrew Hamill and Tony Pickford

1-84312-308-8

LEARNING

in the
ARTS

Andrew Hamill

 David Fulton Publishers

David Fulton Publishers Ltd
The Chiswick Centre, 414 Chiswick High Road, London W4 5TF

www.fultonpublishers.co.uk

First published in Great Britain in 2006 by David Fulton Publishers

10 9 8 7 6 5 4 3 2 1

David Fulton Publishers is a division of Granada Learning Limited.

British Library Cataloguing in Publication Data
A catalogue record for this book is available from the British Library.

ISBN: 1 84312 313 4 (EAN: 978 184312 313 2)

Typeset by Servis Filmsetting Ltd, Manchester
Printed and bound in Great Britain

Contents

CD contents

Resources and links (MS Word)
Certificate Read-Me (Text file)

Project 1
- Project 1 Completion Certificate (MS Word)
- Project 1 Completion 'Star' Certificate (MS Word)
- *Using Textease* booklet (MS Word)
- Train.te (Textease file)
- Project 1 Evaluation (MS Word)

Project 2
- Project 2 Completion Certificate (MS Word)
- Project 2 Completion 'Star' Certificate (MS Word)
- *Harvesting Web Resources* booklet (MS Word)
- *Web Browsing with Internet Explorer & Managing Favorites* booklet (MS Word)
- Project 2 Evaluation (MS Word)

Project 3
- Project 3 Completion Certificate (MS Word)
- Project 3 Completion 'Star' Certificate (MS Word)
- Project 3 Evaluation (MS Word)

Project 4
- Project 4 Completion Certificate (MS Word)
- Project 4 Completion 'Star' Certificate (MS Word)
- Project 4 Evaluation (MS Word)

Project 5
- Project 5 Completion Certificate (MS Word)
- Project 5 Completion 'Star' Certificate (MS Word)
- Project 5 Evaluation (MS Word)

Project 6
- Project 6 Completion Certificate (MS Word)
- Project 6 Completion 'Star' Certificate (MS Word)
- Project 6 Evaluation (MS Word)

Project 7
- Project 7 Completion Certificate (MS Word)
- Project 7 Completion 'Star' Certificate (MS Word)
- *Handling Data with Starting Grid/Excel* booklet (MS Word)
- Sandwich designer, Electrics and Party spreadsheets (MS Excel)
- Project 7 Evaluation (MS Word)

Project 8
- Project 8 Completion Certificate (MS Word)
- Project 8 Completion 'Star' Certificate (MS Word)
- *Computer Animation: – Using MicroWorlds LOGO and Illuminatus* booklet (MS Word)
- Animated art.mw2 (MicroWorlds LOGO file)
- *First Steps with LOGO* booklet (MS Word)
- Project 8 Evaluation (MS Word)

Project 9
- Project 9 Completion Certificate (MS Word)
- Project 9 Completion 'Star' Certificate (MS Word)
- *Getting Started with Coco2* booklet (MS Word)
- Burglartest.coco (Coco2 file)
- Project 9 Evaluation (MS Word)

Project 10
- Project 10 Completion Certificate (MS Word)
- Project 10 Completion 'Star' Certificate (MS Word)
- Project 10 Evaluation (MS Word)

Acknowledgements

The author and publishers gratefully acknowledge permission to use images from the following parties:

Aspex Software for the AspexDraw screenshots in Project 3.
ArcSoft for the *PhotoImpression 4* screenshots in Project 5.
Logo Computer Systems Inc. (LCSI) for the Microworlds screenshots in Project 8.
Matrix Multimedia for the CoCo2 screenshots in Project 9.
Digital Blue Corporation for the Digital Movie Creator screenshots in Project 10.

Introduction

This book is based on the belief that the integration of information and communication technology (ICT) and subject teaching is of benefit to children's development through the Foundation Stage, Key Stage 1 and Key Stage 2. It focuses on ICT in the context of arts subjects. By incorporating some of the powerful ICT tools described in this book in your planning for the arts, the quality of your teaching and children's learning will improve. Similarly, by contextualising the children's ICT experience in meaningful arts projects, children's ICT capability will be enhanced and extended. *Learning ICT in the Arts* is one of a series of ICT books: Teaching ICT through the Primary Curriculum. The core book for the series, *Progression in Primary ICT*, provides a more detailed discussion of the philosophy behind the approach and offers an overview and a planning matrix for all the projects described in the series.

The activities that are presented here offer practical guidance and suggestions for both teachers and trainees. For experienced teachers and practitioners there are ideas for ways that ICT can be developed through the areas of learning and primary arts curriculum using ICT tools with which you are familiar. For less confident or less experienced users of ICT there are recommendations for resources and step-by-step guides aimed at developing your confidence and competence with ICT as you prepare the activities for your children.

The relationship to the Foundation Stage areas of learning and National Curriculum Programmes of Study (PoS) for Art & Design, Design & Technology (D&T), Music and ICT is described for each project. In some activities, such as Project 2: *Aboriginal art*, the emphasis is on finding things out with ICT. Project 3: *Designing an environment* offers opportunities for developing ideas, and in Project 8: *LOGO animation* and Project 9: *Controlling external devices*, the focus is making things happen using ICT tools. Children are provided with purposeful opportunities to exchange and share information through the *Digital photos* and *Sound pictures* projects (Projects 5 and 6). Throughout all the projects, ways in which children can reflect on their use of ICT or explore its use in society are identified.

The projects do not provide an exhaustive or definitive list of ICT opportunities in the primary arts subjects. Instead, they are tried and tested sequences of

activities, adaptable across the age-range, which ensure that high quality learning in ICT is accompanied by high quality learning in the arts. The projects are closely linked to relevant units in the Qualification and Curriculum Authority (QCA) schemes of work for Art & Design, D&T, Music and ICT. They could be used to supplement, augment, extend or replace units in the ICT scheme of work. Although the projects are not future-proof, they have been designed to take advantage of some of the latest technologies now available in primary schools, such as interactive whiteboards, internet-linked computers and digital cameras.

A note on resources

Investment has improved the level of resources for the teaching of ICT in primary schools in recent years. The arrangement and availability of resources, however, still varies greatly from school to school. Some schools have invested heavily in centralised resources, setting up networked computer rooms or ICT suites. Others have gone down the route of networking the whole school, using wired or wireless technologies, with desktop or laptop computers being available in every classroom. Some schools have combined the two approaches, so that children have access to a networked suite and classroom computers. This book does not attempt to prescribe or promote a particular type of arrangement of computer hardware, but does make some assumptions in relation to the management of those resources. These assumptions are:

- The teacher has access to a large computer display for software demonstration and the sharing of children's work – this could be in the form of an interactive whiteboard (IWB), a data projector and large screen or a large computer monitor.

- Pupils (in groups or as individuals) have access to computers for hands-on activities – this may be in an ICT suite or by using a smaller number of classroom computers, perhaps on a rota basis.

- The school has internet access, and at least one networked computer is linked to a large display, as described above.

- Pupils have access to internet-linked computers and the school has a policy for safe use of the internet.

- Teachers and pupils have access to a range of software packages, including a web browser, 'office' software (such as a word processor) and some 'educational' software. Although this book makes some recommendations with regard to appropriate software, it also suggests alternatives that could be used, if a specific package is not available.

The projects

Each project is presented using the following format:

⊙ a Fact Card which gives a brief overview of the project content and how it links to curriculum requirements and documentation;

⊙ detailed guidance on how to teach a sequence of ICT activities in a subject context;

⊙ information on pupils' prior learning required by the project;

⊙ guidance for the teacher on the skills, knowledge and understanding required to teach the project, including step-by-step guidance on specific tasks, skills and tools;

⊙ clear and specific information about what the children will learn in ICT and the subject;

⊙ guidance on how to adapt the project for older or more experienced pupils;

⊙ guidance on how to adapt the project for younger or less experienced pupils;

⊙ a summary of reasons to teach the project, including reference to relevant curriculum documentation and research.

National Curriculum coverage

The ICT activities described in this book are those which are most relevant to Arts learning and hence not all areas of the ICT curriculum have been covered. The core text for the series, *Progression in Primary ICT,* shows how coverage of the ICT curriculum can be achieved by selecting the most appropriate subject-related activities for your teaching situation and how progression in ICT capability can be accomplished through meaningful contexts. Figure 1 provides an indication of the aspects of ICT which are addressed by the projects in this book.

Coverage of ICT National Curriculum Programmes of Study by each Project

Key Stage 1

Projects:	1	2	3	4	5	6	7	8	9	10
Finding things out										
1a. gather information from a variety of sources					✓					
1b. enter and store information in a variety of forms		✓			✓					
1c. retrieve information that has been stored	✓	✓	✓		✓					
Developing ideas and making things happen										
2a. use text, tables, images and sound to develop their ideas		✓	✓	✓	✓					
2b. select from and add to information they have retrieved for particular purposes		✓	✓		✓					
2c. plan and give instructions to make things happen										
2d. try things out and explore what happens in real and imaginary situations	✓	✓	✓	✓	✓					
Exchanging and sharing information										
3a. share their ideas by presenting information in a variety of forms	✓	✓	✓		✓					
3b. present their completed work effectively		✓	✓		✓					

Key Stage 2

Projects:	1	2	3	4	5	6	7	8	9	10
Finding things out										
1a. talk about what information they need and how they can find and use it										
1b. prepare information for development using ICT, including selecting suitable sources, finding information, classifying it and checking it for accuracy						✓	✓			
1c. interpret information, to check it is relevant and reasonable and to think about what might happen if there were any errors or omissions										
Developing ideas and making things happen										
2a. develop and refine ideas by bringing together, organising and reorganising text, tables, images and sound as appropriate					✓	✓	✓	✓		✓
2b. create, test, improve and refine sequences of instructions to make things happen and to monitor events and respond to them								✓	✓	
2c. use simulations and explore models in order to answer 'What if … ?' questions, to investigate and evaluate the effect of changing values and to identify patterns and relationships							✓	✓		✓
Exchanging and sharing information										
3a. share and exchange information in a variety of forms, including e-mail					✓			✓		✓
3b. be sensitive to the needs of the audience and think carefully about the content and quality when communicating information						✓		✓		✓

Figure 1

Focus age groups for each project

Figure 2 provides an indication of the age group for which each project has been written. However, most activities can be adapted for older or younger children and guidance on how this can be done is provided in the information for each project.

Year groups covered by each project

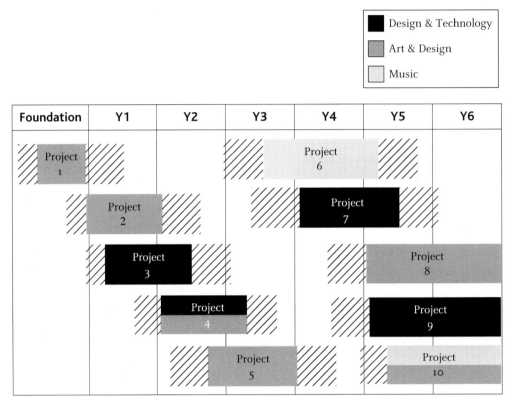

Figure 2

Links to the QCA scheme of work for ICT

Figure 3 indicates the relationship between the projects included in this book and the QCA ICT units in Key Stages 1 and 2. Three types of relationship are indicated in the table; projects which replace a unit, projects which support a unit and projects which extend a unit. By consulting Figure 3 it is possible to see at a glance which projects in this book could be used as an alternative to one of the QCA units. The projects which support units could be used alongside QCA units to reinforce or revisit aspects of learning. For children who need additional challenge it is possible to identify projects which extend the learning introduced in specific units of the QCA scheme of work.

Links to the QCA Scheme of work for ICT in Key Stages 1 and 2

Key
- ▨ Project replaces unit
- ▧ Project supports unit
- ▥ Project augments or extends unit

Projects:	1	2	3	4	5	6	7	8	9	10
Unit 1A: An introduction to modelling	▨	▧	▧	▧						
Unit 1F: Understanding instructions and making things happen								▧		
Unit 2B: Creating pictures	▥	▧	▥	▧	▧					
Unit 2D: Routes: controlling a floor turtle								▧	▧	
Unit 3A: Combining text and graphics		▥								▧
Unit 3B: Manipulating sound					▨					▧
Unit 3D: Exploring simulations							▥			
Unit 4B: Developing images using Unit repeating patterns					▨					
Unit 4E: Modelling effects on screen							▥	▧		▧
Unit 5A: Graphical modelling					▥					
Unit 5E: Controlling devices								▥	▥	
Unit 6A: Multimedia presentation										▨
Unit 6B: Spreadsheet modelling							▥			
Unit 6C: Control and monitoring– What happens when …?							▥			

Figure 3

Project Fact Card: Project 1: Building pictures

Who is it for?

- 3- to 5-year-olds (NC Levels 0–1)

What will the children do?

Using a prepared file containing graphic elements children build pictures by repositioning and recolouring each element to create their own pictures. The activity can be undertaken using a tablet PC or whiteboard if the use of the mouse is inappropriate.

What do I need to know?

- The difference between paint and draw software
- How to use simple draw tools to create basic shapes
- How to select, move and change the attributes of graphic objects
- How to lock elements of drawings in place

What should the children know already?

- How to recognise some icons and make choices with the help of an adult
- How to select tools and objects by pointing and clicking

What resources will I need?

- Drawing software such as BlackCat *Designer*
- Whiteboard, tablet PC or touchscreen will help

What will the children learn?

- That ICT is used in a variety of ways in the world around them
- That using ICT in learning is enjoyable and can be an interactive experience
- To drag items on screen
- To communicate their ideas and thoughts by using ICT tools

How to challenge the more able

- Encourage children to co-operate, to negotiate when making decisions and take turns
- Encourage children to work with increasing control
- Introduce the resizing of objects
- Show how to print work
- Show how to save and finish work at a later time

How to support the less able

- Use an interactive whiteboard to help with selecting objects and icons
- Support their hand movements
- Assign an adult helper to collaborate and help with decision making

Why teach this?

- This project is targeted at ICT NC KS1 PoS Statements 1c, 2d and 3a, but also aims to address elements of the Foundation Stage guidance, particularly 'Knowledge and understanding of the world', 'Creative development' and 'Physical development'.
- It enables children to explore a program on the computer and perform simple functions using the tools and icons and to be divergent, creative and imaginative in their thinking rather than seeing the task as a jig-saw. Children also have opportunities to develop aspects of physical development using gross motor skills on the whiteboard or finer control on other input devices such as tablet PCs or with a mouse. The project enables the exploration of colour and shape in two dimensions with the provisional nature of decision making that ICT offers. The practitioner has an ideal opportunity to respond to children's questions and initiate a dialogue about their creations and the role the ICT has in the process of design, in play and in the world of work.
- The modelling aspect of this project provides a link to QCA ICT Scheme of Work Unit 1A and through adding to their work with paint tools it supports Unit 2B.

Building pictures

What will the children do?

This project can be tailored to the needs of children as a group activity, with or without a practitioner, or for individual children to choose. You first of all need to prepare a file using graphic drawing software. The example below uses the simple draw tools available in BlackCat *Designer*. Although the task is not completely impossible using paint software, the facility to click and select objects afforded by graphic drawing software makes it the software of choice for this project (see 'What do I need to know?' below).

Activity: Picture building

The children are encouraged to build pictures by exploring the way in which each element can be repositioned and how the colours can be changed to create their own designs.

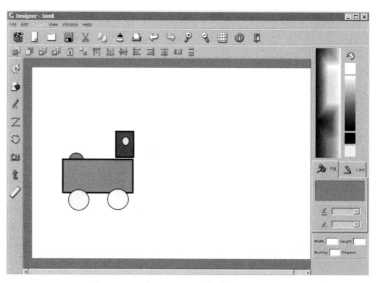

Choosing colours using Blackcat Designer

The file that you have prepared should be open on the screen with the objects that you have drawn already scattered around the screen. They could be coloured in or be outlines only. The children's task is to move the elements by clicking and dragging. While dragging can be a challenging task with a mouse as the button needs to be held down while the object is moved, the challenge can be valuable learning for some children. Others may find a whiteboard, where objects can be selected and moved using their fingers, preferable. Alternatively, a tablet PC, which is supplied with a stylus to select objects by directly touching the screen, could be used.

Once the object has been moved different colours can be tried by clicking on colours in the palette while the object is still selected.

What should the children know already?

How to recognise some icons and make choices with the help of an adult

It is possible that a task of this type could be used to introduce children to computer use. In that event the activity will need to be carried out collaboratively in the first instance so that the child can make choices with the help of an adult. A degree of involvement and interaction for a first-time user could be achieved by simply recolouring an existing picture. With the effects window open already, the child can choose an item in the picture by clicking on it and then recolour it by clicking on a new colour in the palette.

How to select tools and objects by pointing and clicking

Children who already know how to recognise the icons and select tools and objects by pointing and clicking should be able to carry out the task independently. Ways in which the level of challenge can be adjusted for more experienced children are discussed below.

What do I need to know?

The difference between paint and draw software

There are several key differences in the way that paint and draw software behave. It helps to think of objects in draw software as floating in front of the 'paper' whereas paint objects appear to become part of the background. The elements of a drawing file can therefore be selected and moved by pointing, clicking and dragging. Paint objects, on the other hand, can be selected by dragging a box or lasso around them but any background selected may also be moved.

Another advantage of draw software is seen when you resize an object. Objects in *Draw* are created by mathematical formulae using vectors (they are sometimes called 'vector drawing' packages) so when they are resized they are effectively redrawn and

so keep the smoothness of their shape. *Paint*, on the other hand, enlarges the dots or pixels and will become coarse when enlarged.

One advantage of paint software for some tasks is that you can rub out or edit elements dot by dot (pixel by pixel) whereas with draw elements you cannot.

How to use simple draw tools to create basic shapes

Any draw software will have shape tools, at least circle, rectangle and line:

These can be combined to make compound shapes. Shapes are drawn in the first place by selecting a tool and clicking and dragging the shape out on the screen. Shapes can be filled with colour and the line thickness and colour can usually be altered also. For little fingers a fairly thick line is a good idea to aid with selecting as for 'empty' shapes the pointer may need to be directly on the line. In order to create shapes like the train body above, shapes can be combined or grouped. You should expect to find 'group' and 'ungroup' icons or menus in your draw software. The process needed to group two or more shapes – in this instance a rectangle with a circle behind – involves selecting both objects and selecting the group command. Some software allows you to select the first object and then hold down **Shift** (⇧) or Control (Ctrl) while you select the second, so that the first object is not de-selected. In other cases you can click and drag a rectangle around the objects that you wish to select.

In *Designer*, select all the objects you wish to group together by clicking on each object in turn while holding down the **Shift** key at the same time. Then click on the **Group** icon, or select **Group** from the **Object** menu.

As draw objects 'float' on the page they can be positioned behind or in front of other objects using **Higher** or **Lower** commands or **Bring to Front** and **Send to Back**. In *Designer*, **Bring to Front** and **Send to Back** are found in the **Object** menu, or by clicking on the icons on the toolbar:

How to select, move and change the attributes of graphic objects

In nearly all software, selected graphic objects will have 'handles' around them like little squares. When selected:

- ⊙ clicking and dragging in the middle of the object will move it;
- ⊙ pressing backspace or delete will delete it;
- ⊙ selecting a new fill or line colour will change colour;
- ⊙ clicking and dragging in a corner handle will resize it – hold down **Shift** while you do this to keep the aspect ratio or proportion;
- ⊙ selecting **Send to Front** or **Send to Back** or equivalent menu option will raise the selected object up or down the layers – there are often many layers.

You may also be able to rotate or flip the shape – clicking and dragging the blue 'handle' on a *Designer* object enables you to rotate it.

How to lock elements of drawings in place

There may be occasions when you want parts of the draw file that you have created for the children to remain in place while the children move other elements. For example, a background could be moved by accident if the children miss the object that they were trying to select. Most software enables objects to be locked in place. In *Designer* you need to select the object and then choose **Lock** from the **Object** menu or by clicking on the icon on the toolbar. **Unlock** in the same menu enables you to edit all the elements.

A Textease booklet and an example file are provided on the CD-ROM accompanying this book.

What will the children learn?

That ICT is used in a variety of ways in the world around them

Clearly children will not automatically learn about the use of ICT in the world through carrying out this activity. As with so many learning activities the quality of the experience hinges on the thoughtful intervention of the practitioner. Looking at simple designs like cereal packets, for example, and asking 'I wonder whether they used a computer?' can help children to make connections with their own use of ICT. Encouraging children to evaluate the effects of the changes that they make will help to emphasise the way that modelling with ICT can help the decision-making process. If you ask 'Does it look better this colour or shall we change it back?', then the temporary nature of the changes that are made until the design is printed will become clear.

That using ICT in learning is enjoyable and can be an interactive experience

This type of activity can be very empowering for young learners and should be fun. All children can be invited to make a contribution even if, initially, it is a choice between two alternatives. There are no wrong answers but the full potential of the learning in this activity will only be drawn out by encouraging children to talk about their decisions and to become active in trying out alternatives.

To drag items on screen

It is easy to underestimate young children's ability to become adept at using input devices. (I even came across a class that had been taught to hold the mouse the wrong way round – try it!) Controlling touchpads, roller-balls and styluses on tablets or whiteboards are all part of a child's physical development as much as the more traditional technologies – crayons, pencils, brushes. The dragging technique needs practising with any of the devices. Although the gross nature of the movement using a whiteboard and finger may be appropriate for some children, others will benefit from the challenge of using other forms of input. An adult hand helping with guidance or control in the first instance may be appreciated. Wearing a finger puppet can help little fingers drag objects on a whiteboard.

To communicate their ideas and thoughts by using ICT tools

At whatever stage of development it is important that this activity gives children an opportunity to communicate their own thoughts and ideas. 'Show me what you think!' or 'Is that how you want it to look?' and similar questions will help children to realise that their ideas are valued. It is often when struggling to achieve a desired effect of their own choosing that children will learn most.

Challenging the more able and supporting the less able: modifying the project for older and younger pupils

Effective integrated use of ICT cuts across the areas of learning. In this case elements of 'Knowledge and understanding of the world', 'Creative development' and 'Physical development' as well as a Personal, social and emotional development'. The task can therefore be extended or supported in a variety of ways.

If the physical challenge is inappropriate, then the use of an interactive electronic whiteboard may enable some children to access the activity. Whichever input device is used, the challenge of the task can be differentiated by the size and detail of the drawing objects that are put on the screen. Some children could be challenged to line objects up more precisely and avoid overlap. Some 'hand holding' (literally!) can support very young children and help them to make a start with the task.

Children can be challenged by the complexity of the task to develop their use of ICT. The number of functions or techniques can be altered. Some, for example, could be shown how to resize elements or copy and paste to create new elements.

Others may be shown how to rotate some of the elements or be encouraged to save their work and retrieve it later. It is possible to make the children responsible for printing their work too.

Where social development is important the task can be structured so that discussion and shared decisions are included and turn taking can be required or negotiated. ICT, through its provisional nature, can enable collaboration as each child can show how he/she wants an idea to look on the screen and then reverse the decision. The extent to which the practitioner or assistant takes part in the negotiation and decision can help to differentiate the task and will be an effective way of helping children's social and emotional development.

Why teach this?

As well as addressing elements of 'Creative development' and 'Knowledge and understanding of the world' there are opportunities to contribute to 'Physical development' and 'Personal, social and emotional development'.

By helping children to explore a simple program on the computer and perform simple functions using the tools and icons, a contribution to their knowledge and understanding of the world is made. Careful questioning and providing examples of graphic design in the wider world within the setting will enrich this activity. A similar draw file with a SALE poster could be loaded on a computer in the role-play area, for example. The children keeping shop could be encouraged to produce their own poster to display. The practitioner has an ideal opportunity to respond to children's questions and initiate a dialogue about their creations and the role that ICT has in the process of design, in play and in the world of work.

Creative development can be stimulated by the type of shape provided in the initial file. Simple, non-specific shapes will encourage children to be divergent,

creative and imaginative in their thinking rather than seeing the task as a jig-saw. The project also enables the exploration of colour and shape in two dimensions with the provisional nature of decision making that ICT offers.

Aspects of physical development will be enhanced through the use of gross motor skills on the whiteboard or finer control on other input devices such as tablet PCs or with a mouse. Opportunities to develop children's control over their physical movements abound.

Some of the ways in which this project can be adapted to promote personal and emotional development are described in the section above.

See *Learning ICT in the Humanities* Project 1 (*Decision making with a mouse*) and *Science* Project 1 (*Drag and drop sorting*) for related activities.

Project Fact Card: Project 2: Aboriginal art

Who is it for?

- 5- to 7-year-olds (NC Levels 1–3)

What will the children do?

Insert and position images taken from examples of Aboriginal art available online to create their own composition. The pictures can be developed using tools from computer-based paint or draw packages or other media.

What should the children know already?

This could be the children's introduction to any software of this kind, if supported appropriately. But they may know:

- How to select and move graphic objects
- How to select tools
- That moving the mouse controls the current tool selected on the screen

What do I need to know?

- How to search and locate images on the internet safely
- How to copy information in graphic form from a web browser to a simple paint program
- How to select parts of image files and save them
- How to organise files
- How to insert images in a document and position them
- How to make a file 'Read-only'
- How to use the draw and paint tools to make marks

What resources will I need?

- Internet connection and browser
- Paint software such as *MS Paint* or BlackCat *Fresco*

What will the children learn?

- To arrange and rearrange graphic objects on a page to create their own artwork
- To select and use tools to make different marks on the page
- That their artwork is provisional until printed
- That information can be presented in a variety of forms and collected from a variety of sources
- That images can be created by combining and manipulating objects

How to challenge the more able

- Extend the range of tools that the children use to add to their artwork
- Use copy, paste, rotate and flip to develop their ideas
- Show children how to select, crop and insert new elements from pictures
- Show children how to search and locate additional images on the internet

How to support the less able

- Create a document containing appropriate graphics already inserted for children to edit and modify
- Consider using the whiteboard or an alternative to the mouse, e.g. a graphics tablet

Why teach this?

- This project is targeted at ICT NC KS1 PoS statements 1b,1c, 2a, 2b, 2d, 3a and 3b and also gives an excellent opportunity to discuss the use of ICT for creating art as required by sections 4a–c of the 'Reviewing, modifying and evaluating work as it progresses' strand of the ICT PoS.
- The content of QCA ICT Scheme of Work Units 1A and 2B is augmented and extended through this project. It also provides a valuable link to Unit 3A, when many of the skills developed here can be extended.
- The project provides an appropriate ICT opportunity as suggested in the Art & Design NC. All aspects of the Art & Design PoS can be developed through this project whether ICT is used as the medium or as a tool to encourage the children to evaluate and develop their work before completing it in other media.

Aboriginal art

What will the children do?

Ideally, as part of a larger topic where the children have had the opportunity to appreciate and learn about Aboriginal art, the ICT activities described in this project can be used as finished artwork in themselves or as a way of modelling initial ideas that can be developed and created in paint and other media. The activities start with a form of electronic collage using a paint file containing elements of Aboriginal art copied from the internet. The children are helped to choose the elements that they wish to use before using the select tool to copy, paste and position them according to their own designs. The eraser and round paintbrush tool are then used to add to the collage and create their own art.

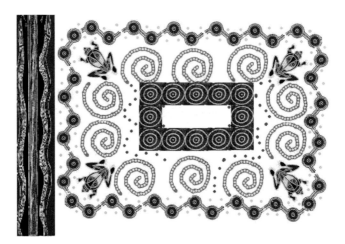

Assembled elements of Aboriginal art to make a new pattern using MS Paint

Activity 1: Select and trim

Starting with the collection of elements that the teacher has prepared (see 'What do I need to know?', below) the children are taught how to use the select tool to delete the unwanted elements from the screen.

The difference between pasting an opaque or transparent background is demonstrated and explained. Using select, copy and paste the elements that the child wishes to use are duplicated and arranged and rearranged to experiment with different effects. Teaching the children to save their work and return to it later is good experience. Saving as they go along will also enable children to revert to a previously saved version if they make changes that would take too long to undo – *Paint* will allow you to undo up to the last three actions. To open a previously saved version, close the file and when asked to 'Save changes' select **No**. The earlier version can then be opened.

Activity 2: Rotate and flip

Once the children are able to select and position the elements that they require, they may wish to rotate or flip over some elements to achieve symmetry in their design. If they require parts of their picture to appear like the frogs in the image at the start of this section, for example, then as they paste each new element, it can be rotated or reflected by selecting **Flip/Rotate. . .** from the **Image** menu. The dialogue box above will appear and the choices that they make will be applied to the selected shape. Useful mathematical learning can take place by exploring the effect

of rotating and flipping as the children orientate and place the elements of their design.

Activity 3: Compose and paint

The final part of the ICT process involves using the eraser, pipette (or pick colour) and paintbrush tools. As one of the key distinguishing features of Aboriginal art is the dot-painting technique, using the round paintbrush in *Paint* allows children to move the brush and add dots to their design at the click of the mouse. In addition using the pipette tool enables the children to choose the colour with which they wish to paint, from any of the elements already on the screen. Previous discussion about the Aboriginal colour palette and even the sources of the pigments will help as the children consider the colours that they select. In paint software, unlike vector drawing (see Projects 1 and 4) any part of the picture can be erased by selecting the eraser or rubber tool and clicking or dragging. It is possible for the children to remove parts of elements in this way, but beware: the rubber tool in *Paint* is just as popular as its non-electronic counterpart!

What should the children know already?

How to select and move graphic objects

There is plenty of opportunity to extend children's capability with this project but, at the same time, it can afford a feeling of achievement for those with very little previous experience. Indeed the initial selecting and positioning activity could be the children's introduction to any software of this kind, if supported appropriately. For children with knowledge of selecting and moving graphic objects, techniques in the selection of precise parts of the image for duplication and more accurate use of the eraser and paintbrush tools for editing can be developed.

How to select tools

Children may need reminding how to select tools and to remember to switch from one tool to another as they work; previous knowledge of other types of software will help.

That moving the mouse controls the current tool selected on the screen

Children should also have some understanding that moving the mouse controls the current tool selected on the screen. The possibility of using the zoom facility in *Paint* can enable quite detailed editing for those who are ready for the challenge.

What do I need to know?

How to search and locate images on the internet safely

Many schools now restrict access to facilities like Google Image Search. Although there are plenty of distasteful images available on the internet, using some common sense in the selection of keywords that you put in a search engine and using the preferences available in most search engines should enable you to locate thousands of images without being shocked by the results. Google in fact by default has its 'Safesearch' options set to 'moderate' which will filter out explicit images. Searching for 'aboriginal art' should return enough images to choose suitable pictures. For this project you need to cut elements from pictures so most pictures will have an element or two that you could use. Once the images appear in the search engine it is important to click on the image to see it full size before you save it to your local disk.

How to copy information in graphic form from a web browser to a simple paint program

Once you have located a picture that you wish to use and can see it full size on the screen, click on it with the button on the right side of the mouse. The menu on the right should appear and if you select **Copy**, with the left mouse button this time, then a copy of the picture can be saved. Open *Paint*, which is available in **Accessories** in the **All Programs** menu in Windows, and then select **Paste** – either from the **Edit** menu or by right clicking again. The image that you copied should now appear in the *Paint* window. Further assistance with web browsing and harvesting web resources can be obtained from the booklets on the CD-ROM accompanying this book.

How to select parts of image files and save them

With the image open in *Paint* you now need to select the part that you want the children to use in their collage.

Use the select tool which looks like a dotted rectangle to drag a rectangle around the part of the image that you require. If you do not get it quite in the right place first time just click anywhere to de-select and try again. When the selection is accurate you need to save a new file containing just the part that you have selected. You save your selection by selecting **Copy To . . .** from the **Edit** menu.

The **Save As** dialogue box will appear and the file needs to be named and saved in an appropriate location in the normal way.

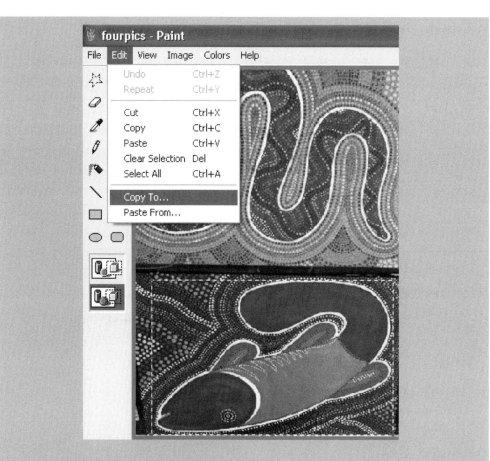

How to organise files

It would make sense to create a new folder for these images, which can be done when saving, by clicking on the new folder icon at the top of the **Save As** dialogue box.

How to insert images in a document and position them

Once you have a collection of files containing the elements that you want to be available for the children to create their collage, it is time to create the *Paint* file that the children are going to use as their starting point. Create a new blank *Paint* file by opening *Paint* or selecting **New** from the **File** menu. A blank file should appear and it can be resized by dragging on the 'handles' – the little blue squares on the corners of the 'paper' and in the middle of the sides.

The elements that you have saved can now be inserted by using **Paste From . . .** in the **Edit** menu. You will need to navigate to the folder that you have created and select each of the elements file by file. They will automatically be pasted into the top left-hand corner of the screen but while they are selected you can move them around the edge. Leave space between each element for the children to be able to drag the select tool around them. Save the file under a new name ready for the children to access.

How to make a file 'Read-only'

collection Properties

| General | Security | Summary | NetWare Version |

collection

Type of file: JPEG Image

Opens with: Windows Picture and F [Change...]

Location: C:\Documents and Settings\ahamill\My Documents

Size: 107 KB (109,994 bytes)

Size on disk: 108 KB (110,592 bytes)

Created: 31 December 2004, 12:03:09

Modified: 31 December 2004, 12:03:09

Accessed: 31 December 2004, 16:03:25

Attributes: ☑ Read-only ☐ Hidden [Advanced...]

[OK] [Cancel] [Apply]

With a file of this sort it makes sense to make it 'Read-only' so that when the children start work on it they cannot select **Save** and write their changes over the file and destroy your hard work. 'Locking' a file in this way is easily done:

1. Locate the folder containing the file through **My Computer**
2. Right click on the file icon
3. Select **Properties** from the menu
4. Click in the box marked 'Read-only'
5. Click **OK**

How to use the draw and paint tools to make marks

The principle for any of the tools is the same and most paint and draw software behaves in the same way. First select the tool that you want to use, by clicking on the icon in the toolbar, and then move the pointer to where you want to begin. Then click the left mouse button and keep it depressed while you move the mouse (drag) to where you want to stop and let go. Paint – for dots in this case – can be applied a click at a time and the rubber can be used in the same way. When a tool is selected, options – like brush shape and size – become visible below the toolbar. Selecting a colour with the pipette tool will display the chosen colour as the active colour at the end of the colour palette. Any marks that you make will be in the active colour until you change it, either by clicking on a colour in the colour palette or by using the pipette again.

The two icons at the bottom of the toolbar enable you to select an opaque or transparent background when you paste. The transparent background makes it possible to draw a 'select' dotted rectangle around a shape and copy it. When you paste, the shape can be moved close to other objects or overlap them without any visible background.

What will the children learn?

To arrange and rearrange graphic objects on a page to create their own artwork

The extent to which the computer printout is the finished artwork will not alter the potential of this project for developing ICT capability. The screen-based work could be used as an initial plan for a painting or could be incorporated into a more complex piece by painting over the printout. In either case the children will still have had the opportunity to make decisions about their work and use ICT tools to help to evaluate the effect.

To select and use tools to make different marks on the page

Although the project uses a limited number of *Paint* tools, there are opportunities for the children to learn about the different tools and to learn to choose the appropriate tool for the task.

That their artwork is provisional until printed

Understanding the provisional nature of electronic paint is a very liberating and powerful thing to learn. Building children's confidence to 'have a go', knowing that they can try out an effect and undo it without a trace, is a valuable feature of this project.

That information can be presented in a variety of forms and collected from a variety of sources

Sharing with the children the source of the images, and how information about Aboriginal art in the form of text exists on many of the websites also, will contribute to their understanding of the nature of information and the variety and number of different sources.

That images can be created by combining and manipulating objects

Reflection and discussion on their work and their use of ICT is important if children are to understand how they may use this software in the future. A discussion of alternative ways that they could have created their images without the use of ICT will also help to confirm their understanding of the ways that the elements they used have been manipulated in the software.

Challenging the more able and supporting the less able: modifying the project for older and younger pupils

As the activities only use some of the functions of the software there is always the opportunity to extend the range of tools that the children use to add to their artwork. It is important, however, as we are discussing the ways in which we can teach ICT capability through subjects in this series, that any stretching of the children's ICT capability is carried out with integrity for the artwork. Using the spray tool, for example, would be inappropriate in this context and working with the rectangle tool may be more appropriate with a topic on Mondrian.

Most children will use copy and paste but the extent to which individuals are challenged to rotate and flip elements to develop their ideas can be differentiated. Some children could also be shown how to select, crop and insert new elements from pictures that were not included in the original *Paint* file, or how to search and locate additional images on the internet if there is a particular design that they are trying to achieve.

For children who may struggle with the complexity of the task a document containing a number of appropriate graphics already inserted and duplicated for children to edit and modify or even solely requiring dots of paint to be added could be prepared. If the child is struggling with the degree of control required to manipulate the elements, then a file with fewer larger elements may help. Similarly, a whiteboard or an alternative to the mouse like a graphics tablet or tablet PC could make the task accessible. Some children find the gross movement on a large interactive electronic whiteboard easier than a mouse, but it is not always helpful as dragging elements over a larger distance can be difficult. If the stylus or child's finger loses contact with the board, the element is 'dropped'. Wearing a finger puppet, as suggested before, can help with this procedure.

Why teach this?

This creative project gives an excellent opportunity to discuss the use of ICT as a medium for art as required by sections 4a–c of the 'Reviewing, modifying and evaluating work as it progresses' strand of the ICT PoS. It particularly focuses on the 'Developing ideas' strand, giving young children a chance to explore and model their ideas in order to evaluate the consequences of their decisions. They also have opportunities to communicate and exchange their ideas with their peers. In particular the task is targeted at ICT NC KS1 PoS statements 1b,1c, 2a, 2b, 2d, 3a and 3b.

The project augments and extends the content of QCA ICT Scheme of Work Units 1A: *An introduction to modelling* and 2B: *Creating pictures* and also provides a valuable link to Unit 3A: *Combining text and graphics*, when many of the skills developed here can be extended.

The project is also an appropriate ICT opportunity as suggested in the Art & Design NC. All aspects of the Art & Design PoS can be developed through this project whether ICT is used as the medium or as a tool to encourage the children

to evaluate and develop their work before completing it in other media. The activities in the project could be adapted to enhance elements of the QCA Art Scheme of Work Units 2A: *Picture this!* or 3B: *Investigating pattern.*

See *Learning ICT in the Humanities* Project 3 (*Using an information source*) and *Maths* Project 5 (*Symmetry and tessellation*) for related activities.

Project Fact Card: Project 3: Designing an environment

Who is it for?

- 6- to 7-year-olds (NC Levels 1–2)

What will the children do?

Select and position a range of graphic objects to design their own playground structure. The ICT modelling will take place alongside 3D modelling with construction kits and materials. The software will also be used to communicate 'final' designs.

What should the children know already?

- How to select and move a graphic object – although this activity could be an introduction to graphical modelling. If an interactive whiteboard is available, then the opportunity to carry out the activity with fingers at the board and subsequently with the mouse at the screen should be taken.

What do I need to know?

- How to use an appropriate graphics package
- The difference between vector drawing software and paint software
- How to select, resize, combine and move graphics
- How to lock and clone elements if the feature is available with the software
- How to operate the interactive whiteboard

What resources will I need?

- Drawing software such as *aspexDraw* (Aspex Software) or BlackCat *Designer*
- 3D materials
- Interactive whiteboard

What will the children learn?

- To select, move, rotate and resize graphic objects
- That images can be created by combining and manipulating objects
- That pictures can provide information and computers can represent real situations
- That a computer representation allows them to make choices, explore alternatives and evaluate different outcomes

How to challenge the more able

- Challenge them to represent their models more accurately
- Teach them about layers and how to move objects behind or in front of others
- Teach them how to add elements using other tools

How to support the less able

- Provide a limited range of objects on the screen that only require moving
- Allow them to use the interactive whiteboard – if appropriate

Why teach this?

- The project focuses on the ICT NC KS1 PoS statements 1c – in that they will be working with a previously stored file; 2a, 2b and 2d – with respect to the modelling aspects of the work; and 3a and 3b – when communicating their designs. There are also opportunities to discuss the use of ICT for modelling as they modify and evaluate their work.
- The activity complements the content of QCA ICT Scheme of Work Units 1A and 2B and could be used with appropriate graphics with children in the Foundation Stage.
- The ICT opportunities advised to support D&T at Key Stage 1 include the use of software to generate and communicate ideas as proposed by this project. ICT models also encourage and facilitate the type of evaluation described in section 3 of the PoS. The playground context is Unit 1B of the QCA Scheme of Work for D&T but this type of draw file could be created to support many design and make activities to allow children to evaluate alternative choices when designing.

Designing an environment

What will the children do?

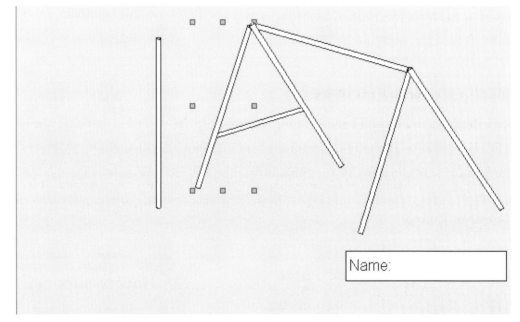

Cylinders formatted to represent straws using aspexDraw *(developed in the UK by Aspex Software)*

This project uses ICT to provide children with an interactive two-dimensional representation of the three-dimensional materials that they are using to construct playground models. If children are going to develop their spatial awareness and design effectively, then their drawing and practical making opportunities need to proceed side by side. By using some of the tools available in a vector drawing package (see Projects 1 and 4) the teacher is able to create on the screen a visual collection of the components that are available for the children to use. In this way the children are able to compose pictures of what they have made and also make models of what they have drawn on the screen. Initially the children will have visited and photographed playgrounds and undertaken focused practical tasks using construction kits, straws, dowel, lollipop sticks and card.

Activity 1: Virtual construction

Using a document prepared using drawing software such as *aspexDraw* or other vector drawing software – *AppleWorks Draw* on the Macintosh or the draw tools in *MS Word* can also be suitable – the children will be taught to drag and drop elements already placed on the screen, to create a drawing of a model that they have made. They will select and move, resize objects and rotate them to achieve a representation of their model.

Activity 2: Modelling possibilities

The second activity is a modelling activity where imagination and design are encouraged to play with possible ideas for a new piece of playground equipment. The provisional nature of the software allows ideas to be explored. New components may need to be added to the initial template so that representations of materials that the children have suggested are included. The teacher can participate in the children's designs by making suggestions or moving components and encouraging the children to evaluate alternatives and use ICT to explore what happens in real situations.

Activity 3: Amending and sharing

The final activity involves the children returning to their previously saved design and amending it to reflect what they actually made in their final playground model. The activity affords two important learning opportunities: it will help to highlight to the children and teacher the extent to which they have put their ideas into practice; and it will show the children how they can organise and share their ideas with others.

What should the children know already?

How to select and move a graphic object

While knowing how to select and move graphic objects would be helpful, this activity could be an introduction to graphical modelling. If an interactive whiteboard is available, then the opportunity to carry out the activity with fingers at the board and subsequently with the mouse at the screen should be taken. The project can be undertaken with very little previous experience. By carefully creating a range of draw elements that fit together – rather like a construction kit – and having them on the screen ready for the children to select and move, most children will be able to succeed. The teaching challenge is to ensure that, for those children already capable, appropriate additional challenges are introduced.

What do I need to know?

How to use an appropriate graphics package

The term 'appropriate' in this case means can it be used to draw separate elements on the screen, select them individually, move them, resize them, rotate them and so on?

Each type of shape should have its own tool to create it. Shapes can be drawn by selecting the required shape tool and clicking and dragging on the 'page' to draw the shape. Once drawn, you should be able to select the shape by clicking on it and move it by dragging it to a different location.

The difference between vector drawing software and paint software

For a discussion of the different software, see Projects 1 and 4. This type of activity needs to be undertaken with drawing software. If none is available, using the *MS Word* drawing tools is preferable to using *MS Paint*. If there are no drawing tools visible at the bottom of the *MS Word* screen, then select the **View** menu and then **Toolbars > Drawing**.

How to select, resize, combine and move graphics

Any changes can be made to a shape using one of the 'handles' (small squares or circles) which surround a selected object. The corner 'handles' will sometimes allow you to resize the shape maintaining its aspect ratio or proportion – alternatively, holding down the **Shift** or **Ctrl** keys while you drag will keep a shape's proportion in some software.

While an object is selected you should be able to change attributes such as fill colour, line colour, type and width.

Drawing software should also allow you to rotate objects either freely by dragging a corner – sometimes after selecting the free-rotate tool – or by entering an angle of rotation in a dialogue box.

Drawing software normally has many layers to it which means that objects can be raised or lowered to give the appearance that one is behind another. Normally an object would be raised or lowered by clicking on it first of all and then selecting **Order** from one of the menus. Some software uses **Higher** and **Lower** while others use **Bring Forward** and **Send Backward** or **Bring to Front** and **Send to Back**. Alternatively software will have an icon which moves the selected object backwards or forwards.

Some simple software may not have all the shapes that you want to include. If a 'Group' option is available, then compound shapes can be made by combining two shapes. For example, if a wheel is required:

⊙ Draw two circles of the appropriate size.

⊙ Then either position one over the other or, if the software allows you to align objects, select both shapes (hold down **Shift** or **Ctrl** on the keyboard while you select the second) and then select **Align Centres**.

⊙ Finally, while they are still both selected, click on the **Group** option either in the menu or on a toolbar and the two elements will become grouped and stay together when they are dragged.

How to lock and clone elements if the feature is available with the software

AspexDraw - playground.adw (Scale 50%)

Edit	View	Style	Transform	Effect	Help

Undo	Ctrl+Z
ReDo	Ctrl+Y
Select All	Ctrl+A
Deselect All	Ctrl+D
Edit	▶
Grouping	▶
Order	▶
Options	

Group	Ctrl+G
UnGroup	Ctrl+U
Group Effects	
Play Group Effects	Ctrl+H

and paste the tube below to d
work

Some software allows elements to be locked to the 'page' so that they cannot be moved. It is a useful facility if there are background objects that you do not want to be moved accidentally when dragging other items. *aspexDraw* uses what it calls 'Group Effects'. It is accessed via **Grouping** in the **Edit** menu although effects can be applied to separate elements. Once effects have been assigned to different objects, selecting **Play Group Effects** will make them operational.

The three options available in *aspexDraw* are:

⊙ **Clone** – which allows children to click on a shape and obtain a copy of it. For example, you could just provide on the screen one of each type of shape. Every time a child clicks on a shape a duplicate or clone can be dragged from it. For software without this function copy and paste will work equally well.

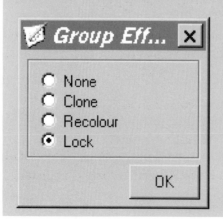

Group Eff... ✕

- ◯ None
- ◯ Clone
- ◯ Recolour
- ⦿ Lock

OK

⊙ **Recolour** – which makes the colour palette appear each time a shape is selected so that it can be filled with a different colour. All drawing software will allow objects to be recoloured by choosing a new colour from the palette while the object is selected.

⊙ **Lock** – which makes it impossible to select an object with this effect applied to it once **Play Group Effects** has been selected.

How to operate the interactive whiteboard

Clearly it helps to involve a large group or class if they can see and join in with a demonstration and interactive whiteboards can certainly have a positive impact on plenary sessions. However, the ease with which objects can be moved on an interactive whiteboard varies, depending upon the model, so the extent to which a whiteboard will support individuals with this project needs to be evaluated by trying it out. There are two possible benefits for individual children using the whiteboard to carry out these activities. The first is the scale; if we are aiming to develop children's gross movement, then working on the large board may help. Remember that it is also possible to use the zoom facility in most software which can help fine-detail work. The other benefit of the whiteboard is avoiding the use of the mouse. An interactive whiteboard is like a large graphics tablet and provides a very different way of interacting with the computer. SMART Boards, which can be operated by a child's finger, obviate the need for any writing implement. Most electronic whiteboards do need a special pen of some sort – some are large like board markers; others are more the size of a normal pen. Dragging, which is central to these activities, can sometimes be problematic with whiteboards as any loss of contact with the board on a long drag causes the object to be dropped. By checking the ease with which the board handles the activities and considering the learning needs of the children, appropriate technology for access to the tasks can be planned.

What will the children learn?

To select, move, rotate and resize graphic objects

One of the key reasons for undertaking this kind of task is to help the children use ICT to help them share their ideas. Encouraging the children to stay true to their ideas highlights the need for them to be in control of the software tools and to be able to position and manipulate the drawing elements accurately.

That images can be created by combining and manipulating objects

The way that the children's designs are constructed from component parts can be emphasised during the activities. For some children it may be appropriate to show how grouped objects were created or, indeed, help them to create their own.

That pictures can provide information and computers can represent real situations

The interspersing of practical model making and computer-based modelling will help to connect the computer aided picture with the children's three-dimensional models.

That a computer representation allows them to make choices, explore alternatives and evaluate different outcomes

Many children will not explore alternatives readily of their own volition. The active engagement of the teacher, or other teaching assistant, in making changes and undoing them, while prompting the children to make a judgement, is an important part of the learning experience.

Challenging the more able and supporting the less able: modifying the project for older and younger pupils

Using even primary drawing software it is possible to demand a level of accuracy that would challenge most of us. Setting an appropriate level of challenge, for each child to represent his/her model as accurately as possible, will help all children to be engaged. For some children it would be appropriate to introduce the zoom facility to line up objects accurately. Most software will allow selected objects to be 'nudged' or moved a tiny amount using the cursor or arrow keys on the keyboard. Some children will not be concerned about the order of different elements – that is, whether one object is in front or behind – but for those who are, teach them about layers and how to move objects behind or in front of others. Some children will also wish to add elements using other tools. A key part of NC Level 2 is that children amend their work and there are plenty of opportunities in this type of project to teach the value of revision.

Simplifying the task to support children who may struggle can be achieved through providing a limited range of objects that only require moving. The cloning facility described above would reduce the complexity of the task that could be presented to less able children. Three different vertical lengths and three different horizontal lengths, for example, could be placed around the edge of the screen. The children would then choose as many of each as they require to make their structure.

Allowing children to use the Interactive whiteboard or other input device may help – see the discussion above – but a careful consideration of the child's needs may determine sometimes that the device which facilitates the completion of the task would be least beneficial for the child's learning.

Why teach this?

Computer Aided Design (CAD) is undertaken in almost every manufacturing enterprise and while it may seem a rather grandiose term to use for this type of infant activity, the purpose is the same. If the children recognise some of the benefits of how drawing software can help them to show what they want to make and to get their ideas across, then the activity is worth while. It is targeted on ICT NC KS1 PoS section 2, 'Developing ideas and making things happen', as modelling is at the heart of this project. It is important that children are given time to develop their ideas and explore alternatives as they modify and evaluate their work (2a, 2b

and 2d) and also to talk about this use of ICT (Breadth of study, 5c). There are also aspects of the project which address the requirements to exchange and share information using ICT (3a and 3b) when communicating their designs to others and their final drawings would also make a good display. To the extent that the children will be working with a previously stored file and need to save it to return to later in the project they should recognise the similarity with other work that they may have entered and saved previously (1c).

The project complements the content of QCA ICT Scheme of Work Unit 1A: *An introduction to modelling*, in that similar tasks are carried out but in a more factual context, and Unit 2B: *Creating pictures*, as similar techniques are applied using drawing as oppose to paint software. It is possible that a comparable task could be undertaken, using appropriate graphics to represent elements of their construction play materials, with children in the Foundation Stage.

The ICT opportunities advised to support D&T at Key Stage 1 include the use of software to generate and communicate ideas as proposed by this project. The fact that ICT models are provisional also encourages and facilitates the type of evaluation described in section 3 of the D&T PoS. Children are more likely to talk about their ideas and engage in evaluation knowing that any changes that they make will not have a noticeable impact on the finished printout. The playground is the context for Unit 1B of the QCA Scheme of Work for D&T (*Playgrounds*) but this type of draw file could be created to support many design and make activities to allow children to evaluate different choices. Unit 2B: *Puppets*, for example, provides the opportunity for a range of different materials to create the facial features on a glove puppet to be presented in a prepared draw file so that the children can model and evaluate alternative designs.

See *Learning ICT in the Humanities* Project 2 (*Map making using GIS*) and Maths Project 8 (*Modelling investigations*) for related activities.

Project Fact Card: Project 4: Designing logos

Who is it for?

- 5- to 7-year-olds (NC Levels 1–3)

What will the children do?

Use a paint package to create an original graphic which will be duplicated and transferred to fabric using iron-on inkjet transfer paper.

What do I need to know?

- How to use the paint software tools
- How to select, copy and paste
- How to flip or rotate part of an image
- How to configure the printer properties to print iron-on transfers
- The differences between *Paint* and vector drawing
- How to change the font used for Windows menus

What should the children know already?

- How to select tools and make marks on the screen – although this project could be the first experience of using paint software that the children have
- How to select menu items

What resources will I need?

- Paint software such as *MS Paint* or BlackCat *Fresco*
- Colour printer
- Inkjet transfer paper

What will the children learn?

- To copy and paste parts of their 'painting'
- To change colours and evaluate their choices
- That images can be created by combining and manipulating objects
- That making marks on the screen and using 'undo' makes it easy to correct mistakes and explore alternatives
- That a screen image can be a finished product
- That pictures can be assembled by repeating elements

How to challenge the more able

- Increase the degree of accuracy required of their logo design
- Require a rotated or flipped element to their logo
- Show how fine editing can be achieved using the zoom facility

How to support the less able

- Create a document containing elements that the children can assemble
- Use an interactive whiteboard and finger to 'paint'
- Encourage simple designs

Why teach this?

- The project is targeted on ICT NC KS1 PoS statements 2a and 2d. It also gives an excellent opportunity to address section 4 of the ICT PoS, 'Reviewing, modifying and evaluating work as it progresses'.
- The project relates to the content of QCA ICT Scheme of Work Units 1A and 2B.
- There are a variety of contexts where this project could be used. It could form part of a larger D&T textiles unit designing faces to be transferred to glove puppets, for example, or part of an Art unit where the coloured patterns generated using ICT form the starting point for further textile painting. The exploration and evaluation parts of the KS1 PoS for Art & Design can be addressed in this way as can the developing and evaluating sections of the D&T PoS. In addition it is an example of a finishing technique (D&T KS1 PoS 2e). The project could support QCA D&T Scheme of Work Units 2B and 2D. There are also opportunities to use the type of activities in this project to add another dimension to QCA Art & Design Units 2A or 3B.

PROJECT 4

Designing logos

What will the children do?

Using Paint *to make repeat patterns*

Plenty of free play opportunities with the paint software that is to be used for this project will help the children become familiar with the tools and behaviour of the software. At the centre of the children's experience are three key uses of ICT. Firstly making marks on the screen using the tools available; secondly copying and pasting or resizing those marks to produce identical images or repeat patterns; and thirdly flipping or rotating parts of their painting to produce symmetrical designs. There are many contexts that make ICT the sensible medium to choose for these tasks.

⊙ Designing logos for the school, a sporting team or the library will make the need to create identical images of differing sizes.

⊙ Decorating bags or book covers or wallpaper makes the use of repeat patterns sensible.

⊙ The task of creating a symmetrical face for a puppet uses the flip capability of most paint programs to good effect.

Activity 1: Making marks

Using the paint tools the children practise making marks and use the colour palette to include different coloured shapes. A number of different challenges can be introduced to develop control of the tools, including following lines and making enclosed shapes that can be filled with colour. Using the fill tool, enclosed spaces can be coloured in and colour choices evaluated. If the paint leaks out, use the **Undo** command which is in the **Edit** menu in most software. The line and shape tools can be introduced too.

Activity 2: Repeating patterns

The second activity introduces the select tools. The pictures created in the first activity could be used or new pictures can be drawn. Initially show how to choose the select tool and pick up part of the image and move it. Then with an element of the picture selected demonstrate how copy followed by paste will produce a copy of that part of the picture. Finally by clicking on the corner of the select box the selected element can be resized or distorted by dragging.

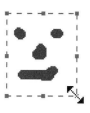

Activity 3: Reflective symmetry

Once the idea of copying and pasting all or part of a design is understood, the possibility of reflecting or flipping a copy of a part of the design to produce a symmetrical pattern can be explained. Some software automatically produces symmetrical designs, but for the purpose of this activity it is important that the children learn how to select and flip elements of their pictures.

Some children may be able to draw half a shape and copy it, but it is probably easier to draw a complete shape and then select half of it. Positioning the select

tool in the right place can offer quite a challenge. If the children are encouraged to drag from right to left when selecting the right-hand side of an image, it can help to make an accurate selection.

In order to create a symmetrical pattern or design the element of the picture which is to be reflected must first of all be copied and pasted. While the pasted element is still selected the flip command needs to be selected. In *MS Paint* the **Flip/Rotate. . .** option is in the **Image** menu. The reflected element can then be aligned with its 'other half'.

Once the children have completed their logos they should be printed out on iron-on transfer paper. It is then a fairly straightforward process for the design to be transferred to cotton fabric with an iron. Using the logo on paper as well – as a poster, for example – highlights another benefit of the use of ICT: the ease with which images can be duplicated.

What should the children know already?

How to select tools and make marks on the screen

If the children have followed Unit 1A in the QCA ICT Scheme of Work, they will have used simple tools in a painting package but this project could be the first experience of using paint software that the children have. The age and experience of the children will have an impact on the time required to complete this type of project, but with support even those with very little knowledge of ICT painting should have some success.

How to select menu items

Depending on the software that is used the need to access menus may not arise. However, if *MS Paint* is all that is available, it is necessary to access the menu buttons which are rather small. By accessing the **Display** control panel from the **Start** menu it is possible to increase the font used for menus and hence the size of the button.

What do I need to know?

If you have not created an image using *Paint,* have a go! Trying to recreate an image on the screen is one of the best ways of testing out the software.

How to use the paint software tools

There are many versions of paint software – some designed specifically for primary children. All follow the convention of selecting the tool and the colour and then clicking and dragging across the screen to make marks. In addition many have fill tools which will apply colour within boundaries as if you have tipped paint in – the tipping paintpot icon is often used to indicate the fill tool. You can use the fill tool to change the colour of an object by clicking on it again with the fill tool after selecting an alternative colour. Most paint software will have a rubber tool to erase and many also have shape and line tools.

How to select, copy and paste

Paint software behaves differently from vector drawing software. Drawing software will allow you to click on an object to select it; *Paint*, on the other hand, needs to be selected with a freehand select tool, sometimes called a lasso, or a rectangular select tool – the dotted box. Sections of the image can be selected with an opaque or transparent background.

Opaque will include any white background in the selection

Transparent will just select any painted shape in the selection and ignore the background

How to flip or rotate part of an image

Once part or all of an image is selected it can be flipped or rotated by selecting **Flip/Rotate...** from the **Image** menu and choosing a horizontal or vertical flip.

How to configure the printer properties to print iron-on transfers

Most printers have a **Properties** or **Setup** option that will cause the printer to adjust its settings to match the type of paper that you are using. When the finished image or logo is ready for printing select **Print...** from the **File** menu. Depending on the type of printer and software that you have a dialogue box similar to the one overleaf should appear.

Clicking on the **Preferences** button will open the **Printing Preferences** window where the paper type can be selected.

As the image is reversed when transferred to fabric you will need to print a mirror image. Most printers offer this option which is available in this case when you click on the **Features** tab.

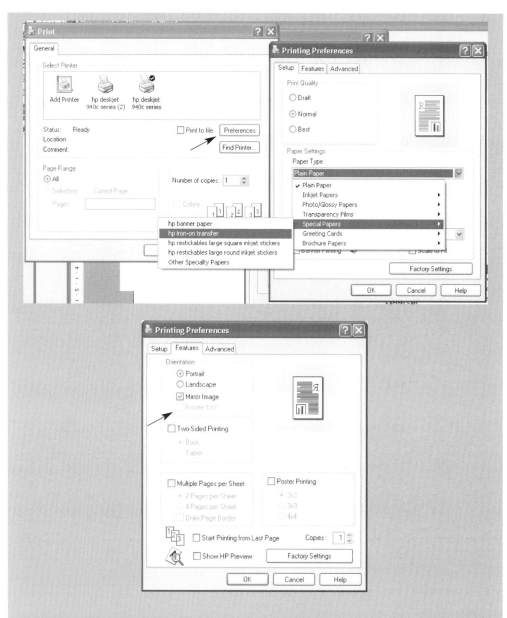

Make sure that the transfer paper is inserted in the printer correctly and then click **OK** in each window. Once the transfer has been printed follow the instructions supplied with the transfer paper to ensure that the image is ironed safely onto the fabric.

The differences between *Paint* and vector drawing

Shapes created in *Paint* effectively become part of the background. The effect is that if you overlap two shapes, selecting one of them and moving it in *Paint* will remove part of the shape behind too. Also if you select a shape and stretch it, it will pixelate – that is, become rough at the edges – as the dots which make up the picture are stretched. Vector drawing software, on the other hand, redraws the shapes as they are enlarged, providing a sharper image. Vector drawing software enables the elements to be selected and moved independently of the rest of the image as elements are placed on different layers in the file. One element can be placed above or below another element and that order can be changed. See the 'What do I need to know?' section of Project 1 for more information.

How to change the font used for Windows menus

If you find that the menu text is too small for you or your children, it is possible to alter the setting in Windows; however, the changes that you make in the **Display Control Panel** will apply to all programs and windows on the computer. The setting can be changed back by following the same process:

1. Select the **Start** menu.
2. Select **Control Panel**.
3. Double click on **Display**.
4. Select the **Appearance** tab.
5. Choose the font size that you require.
6. Click **Apply** and wait for the change to take effect.
7. If the settings look fine click **OK**; if not, go back to 5.

What will the children learn?

To copy and paste parts of their 'painting'

Some discussion about the computer's ability to remember exactly what it copied will help young children understand this process. Young learners may need help both with selecting elements that they wish to copy and with choosing the menus. The children should be encouraged to talk about the effects that they produce and their intentions.

To change colours and evaluate their choices

Clicking with the fill tool in any block of colour will replace it with the active colour – that is, the last one selected from the palette. In this way the children can be encouraged to try out different colour schemes and talk about preferences and in the process learn about the way computers are used to model choices and show alternatives.

That images can be created by combining and manipulating objects

Whether designing abstract shapes or puppet faces, showing the children how to select and move parts of their painting to produce the effect that they require will develop their understanding of the use of ICT and the purpose and benefit of evaluating their work.

That making marks on the screen using 'undo' makes it easy to correct mistakes and explore alternatives

When moving elements they can continue to be moved while the select box is still active and the dotted lines can be seen around the shape. If the children click outside the select box, the element will become de-selected. Selecting the **Edit** menu and clicking **Undo** will reverse the last command. *MS Paint* can undo the last three actions.

That a screen image can be a finished product

Often, from an art education perspective, ICT is best used for its modelling facilities and finished artwork best created using 'real media'. This project also shows how a design produced using a computer can be transferred to fabric and become the finished piece.

That pictures can be assembled by repeating elements

ICT makes the creation of repeating patterns very simple and not laborious or dull as we have historically associated with the term 'repetitive'. The facility with which elements can be copied and pasted helps to encourage children to work in detail on a small section of design which will be quickly repeated to cover a large area.

Challenging the more able and supporting the less able: modifying the project for older and younger pupils

While it is possible to undertake this type of project with very young children, provided that support is available, there is a danger of moving too far or fast for children's understanding. So aim to take small steps and only include those tasks that the children can join in with. At its simplest the children's marks can be copied and pasted several times for printing. It is also possible for you to create a document containing elements that the children can assemble by concentrating on select and move. If there is access to an interactive whiteboard, some children find the use of their finger to 'paint' with large movements easier – and more fun.

Showing the children very simple designs and encouraging them to use the shape tools can ensure that the task does not become frustrating.

For older children or those who need additional challenge increasing the degree of accuracy required of their logo or requiring it to have a rotated or flipped

element can make this a fulfilling activity for almost any age. Using the **Text** tool will prove testing for others in order to include words or letters in their design. Alternatively by using the zoom facility, very fine editing can be encouraged for those who have or need to acquire patience!

Why teach this?

The project is targeted on ICT NC KS1 PoS statements 2a and 2d. Through using the *Paint* program as 'ideas processor' the children are using the modelling power of the technology to share what they imagine their design to look like and try out alternatives. Their use of images to develop ideas will enable the exploration of ICT tools for a real purpose. The project gives an excellent opportunity to address section 4 of the ICT PoS, 'Reviewing, modifying and evaluating work as it progresses'. It is important that opportunities for talk are planned during this project. As actions can be reversed when using 'digital paint', the review process and the possibility of contemplating changes is a real option. We still need to be sensitive to children's creative endeavours, however. By celebrating the work through display or sharing it through use in the school, elements of section 3 of the PoS, 'Exchanging and sharing information', can also be addressed. Use the opportunity to talk about uses of ICT outside school: comparing the *Paint* program with 'real paint' and wondering whether examples of logos printed on packaging were created using a computer will provide the type of breadth to your teaching described in section 5 of the NC PoS.

The project relates to the content of QCA ICT Scheme of Work Units 1A: *An introduction to modelling* and 2B: *Creating pictures*. It extends the *Introduction to modelling* unit with the use of copy and paste and contains the possibility of additional challenges to make it appropriate up to Year 2 and beyond.

There are a variety of contexts where this project could be used. It could form part of a larger D&T textiles unit designing faces to be transferred to glove puppets, for example, or part of an Art unit where the coloured patterns generated using ICT form the starting point for further textile painting. The exploration and evaluation parts of the KS1 PoS for Art & Design can be addressed in this way as can the developing and evaluating sections of the D&T PoS. In addition it is an example of a finishing technique (D&T KS1 PoS 2e). The project could support QCA D&T Scheme of Work Units 2B: *Puppets* and 2D: *Joseph's coat*. There are also opportunities to use the type of activities in this project to add another dimension to QCA Art & Design Units 2A: *Picture this!* or 3B: *Investigating pattern*.

See *Learning ICT in Maths* Project 5 (*Symmetry and tessellation*) for related activities.

Project Fact Card: Project 5: Digital photos

Who is it for?

- 7- to 9-year olds (NC Levels 2–3)

What will the children do?

Use a digital camera to take pictures according to a theme. The pictures will be downloaded to the computer and edited and manipulated using simple photo-editing software. The children will be encouraged to apply effects and evaluate the impact. The final images will be printed out.

What should the children know already?

- How to select objects and click buttons on the screen

What do I need to know?

- How to use the digital camera
- How to transfer the photo files from the camera to the computer
- How to open a photo file in the photo-editing software
- How to resize, copy and paste the image
- How to apply effects and undo
- How to save and print work

What resources will I need?

- Digital cameras
- Photo-editing software
- Printer and photo paper
- Interactive whiteboard will help

What will the children learn?

- That images can be recorded, stored and transferred digitally
- That computer software can process a range of media which gives the user options to explore
- That images can be created by combining and manipulating photographs
- To select and use different techniques to communicate ideas through pictures
- That pictures can be assembled by repeating elements

How to challenge the more able

- Encourage increasing independence with the transfer and saving of the digital photographs
- Introduce the way in which the intensity of the effects can be altered

How to support the less able

- Help with the loading and copying of the images

Why teach this?

- This project can be a very fruitful opportunity to address any of the sections of the ICT NC KS1 PoS depending on the emphasis of the work. At KS2 it is possible to focus on elements of 2a, 3a, section 4 and 5b.
- The activity adds a different dimension to the content of QCA ICT Scheme of Work Units 2B and 4B. It could be carried out by children from Y1 upwards with suitable levels of support or challenge. The evaluation of different filters and effects also supports Unit 5A.
- The project is very flexible and can fit into a range of themes or enhance Units 1A, 2A or 3B of the QCA Scheme of Work for Art & Design. It can assist with understanding visual elements and exploring colour and pattern described in statement 4a of the KS1&2 PoS for Art & Design. The provisional nature of the medium can also encourage the type of investigation described in section 2 and fulfils the requirement for the use of digital media in 'Breadth of Study' requirement 5c (using a range of processes).

Digital photos

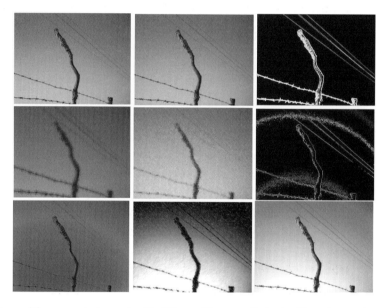

Nine versions of the same photograph with different filters applied using PhotoImpression 4 *(ArcSoft)*

What will the children do?

The focus of this project revolves around the use of digital cameras to frame and capture interesting images which can be repeated and altered using different filters in digital photo-editing software. Most cameras are supplied with some software but more sophisticated results are available using software such as *Adobe Photoshop Elements*. Another alternative is *PhotoFiltre* which is available as a free download (www.photofiltre.com). The work can be placed into context by studying the work of an artist who produces repeat images or patterns such as Andy Warhol or Jasper Johns. It is equally possible to create links to themes that may be part of the Art curriculum, like self-portraits, or may be cross-curricular, like mini-beasts, our school or indeed almost any context that would supply interesting, accessible subjects to be photographed.

Following an introduction to the theme, the children will need to do some activities using view finders. Simple cards with rectangular holes in can help the children to look at their environment or existing photographs and select views which interest them.

Activity 1: Point and click

The first ICT activity needs to familiarise the children with the digital camera and the way that the view finder may display a slightly different view from the image that the camera takes. More sophisticated cameras may offer the opportunity to view the image on the Liquid Crystal Display (LCD) screen at the back of the camera as the picture is taken. Using the display shortens the battery life, however, and it is not vital that children use the LCD for this activity.

Working in groups the children take a series of images which are downloaded to a computer and used in a plenary activity to enable the children to talk about their images and why they selected them. If a data projector is available, sharing images with a class and evaluating them is relatively easy. It is still possible to share the images using a computer monitor although a larger display may be preferable.

> IDEAS!
>
> Hands or feet would work well with 'Ourselves'; pictures of bricks or grass or fabric could relate to 'Textures'; pieces of fruit or other food could be used as part of a 'Healthy eating' project; faces depicting different moods could be used to explore themes in personal or social education.

Activity 2: Filters and effects

Once you are satisfied that the children are able to select views and take pictures using the digital camera they need to become familiar with the effects or filters which they can apply to their photos using photo-editing software. The second activity can be undertaken using photos taken during Activity 1 or images from another source (downloaded from the internet, from a CD-ROM or taken by others). By using images from other sources, it is possible to undertake Activities 1 and 2 in any order or indeed simultaneously if resources make it necessary. For example, half the class could take pictures while the other half are being introduced to the software, which would reduce the number of cameras needed.

First of all open an image in the photo-editing software and demonstrate how the effects are applied and how to undo them. The children then experiment with different filters and effects and are encouraged to evaluate the impact by commenting on the mood or feeling that they associate with the effects.

Activity 3: Compose and create

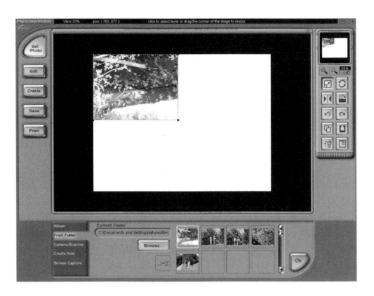

The PhotoImpression *4 screen*

It is important that children are encouraged to talk about their hopes and intentions for their finished artwork before elements of the first two activities are combined in the third activity. Once they have experience of the software, the idea of using several different effects to make a pattern using copies of the same image is introduced. The children should then be encouraged to take more photographs of the chosen theme and think about how they intend to use the effects.

From the digital photos that they take they select one image and open it up in the photo-editing software. The image is then selected and resized to enable multiple copies to be created on the canvas.

Editing the picture by copying and pasting the selection produces a composite image with identical copies of the original photograph. Using the effects which they explored in the second activity the children are able to select each small image in turn and apply an effect of their choice. When they are satisfied with the overall effect the image can be printed out.

What should the children know already?

How to select objects and click buttons on the screen

With the software pictured above (ArcSoft's *PhotoImpression* 4) it is possible to carry out the activities by clicking and dragging and selecting buttons. The buttons also have the hover facility which means that a little pop-up box explains the use of the buttons if the children are unsure. The children also need to understand that the effect they choose is carried out on the part of their image which they have selected. It is possible to use these activities to develop that understanding, although most software applies the principle that the part of a document that you wish to change needs to be selected first.

What do I need to know?

How to use the digital camera

Each camera comes with a manual and you will need to familiarise yourself with the functions of the cameras that you intend to use. There are plenty of relatively cheap 'point and click' digital cameras which will produce pictures of an adequate quality for the purposes of this project. It will need to be a digital camera as the images are captured as computer-ready files and stored in the camera's memory in a format that can be 'read' by the computer.

How to transfer the photo files from the camera to the computer

Cameras have two common ways in which the image files are transferred to the computer for editing. Some cameras come with a lead which usually connects the camera to the USB (Universal Serial Bus) port of the computer. In order for the connection to work, software supplied with the camera needs to be installed on the computer beforehand. Once connected the software often automatically guides you through the transfer process.

Other cameras have memory cards in them which can be removed from the camera and inserted into a card reader attached to the computer. The little cards, of which there are several types, then behave like another disk drive attached to your computer and the files can be accessed and copied to the computer through the **My Computer** icon where an icon representing the card will be displayed.

Copying files

There are so many different cameras which need to be connected to the computer in the way described by the manufacturer to make it unhelpful to describe them all here. However, if you have a camera with a removable card, then the pictures can be transferred as follows:

1. Make sure the camera is switched off and remove the card from the camera.
2. Insert the card in the card reader connected to the computer.
3. If the computer does not automatically open the window for the card, select **My Computer** and navigate to the correct drive (it should be one that is not normally visible in **My Computer** – possibly Drive E or F).
4. If you select **My Computer** again and choose the folder that you wish to store your photos in, a new window should open.
5. Selecting the photo files that you want and dragging them to the folder on your computer will cause the image files to be copied to the hard drive or network location that you choose.
6. It is usually best to delete photos in the camera using the method described in the camera instruction manual, once you have replaced the card in the camera

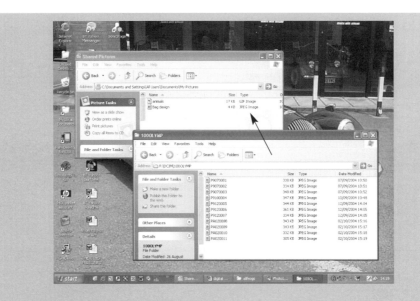

How to open a photo file in the photo-editing software

With most photo-editing software it is best to select and run the software first and then select **Get Photo** or **File** and **Open** from the menu bar. You will then need to browse to find the folder where you have stored the photos.

How to resize, copy and paste the image

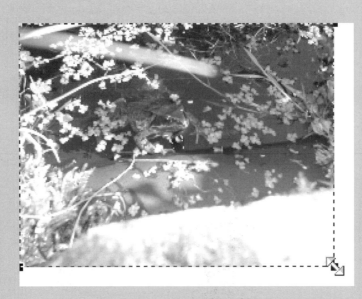

Some software will have a resize option in the **Image** menu but the majority allow you to select an object by pointing and clicking or to choose a part of the image by lasso-ing or dragging a dotted box around the element that you require. To resize the selection and keep its proportion it is necessary to move the pointer over one of the corner handles – that is, the little black squares around the selection – and click and drag until the required size is achieved. Once selected, copy and paste will be available as buttons or options in the **Edit** menu.

How to apply effects and undo

With the appropriate part of the image selected it is necessary to apply the effect or filter that you require. Many photo editors allow you to preview the effect, so have a go! If you do not wish to keep the effect, you either select another one or cancel it. If the preview facility is unavailable, you may need to use the undo option which will either be available as a button or a command in the **Edit** menu.

How to save and print work

Saving and printing work needs to be carefully approached with photos for three main reasons:

1. Size of files
2. Formats of files
3. Using up expensive ink!

Size and formats of files

Because photo files contain information about each dot on a picture, they take up a great deal of storage space. Managing the files of a class needs to be approached carefully, therefore. Most photo-editing software will also enable different formats for you to save. If you want to be able to open the file later and continue to edit it, then you need to save it in the format recommended by the software. If you want to use the image in another application – inserting it into a word processor or including it on a web page, for example – then one of the standard formats, jpeg or gif, can be selected in most software by selecting the one that you require in the **Save As. . .** dialogue box.

What will the children learn?

That images can be recorded, stored and transferred digitally

Although this is fast becoming the way that many people take photographs, the opportunity for the children to carry out each stage and reflect on the process will

provide opportunities to describe 'their use of ICT and its use outside school' (ICT NC Attainment Target Level 3).

That computer software can process a range of media which gives the user options to explore

The central purpose for using ICT in this project is to make use of the facility to explore and develop artwork which this type of software provides. The provisional nature of the effects which the children apply to their work aims to enable them to learn about the power of the medium and encourage a reflective approach to their work.

That images can be created by combining and manipulating photographs

Some of the ways that digital photographs can be altered are introduced in this project. There are also opportunities for the children to 'comment on similarities and differences between their own and others' work' (A&D NC Attainment Target Level 3) as they develop and improve their photographic work.

To select and use different techniques to communicate ideas through pictures

Thoughtful reflection and exploration of the moods and feelings communicated by the effects which the children explore will help them to 'generate, develop, organise and present their work' (ICT NC Attainment Target Level 3). An important feature of this work is the recognition that the projected image or printout can be their art.

That pictures can be assembled by repeating elements

The ease with which ICT can copy and repeat should also be understood through this project so that children will know how to create repetitive patterns in future.

Challenging the more able and supporting the less able: modifying the project for older and younger pupils

As most of the photo-editing software has a range of more advanced functions than we have used in this project, there are a variety of ways that the levels of demand can be increased for the more able. In the initial stages some pupils can be encouraged to be more independent with the transfer and saving of the digital photographs and could act as guides for other groups.

The complexity of the composition of the work can also be increased to include more elements and a greater emphasis on the quality and consideration of the audience for the work. Older or more able children could also be encouraged to compare their use of ICT in the project with traditional photographic methods and, if the software allows, preferences such as the intensity of the effects can be altered. Degrees of subtlety can then be introduced to increase their attention to

detail.

One of the attractions of this project is the way in which, with minimal support, less able pupils can also achieve effective results. Help with the loading and copying of the images in the software should enable most children to explore a range of ideas with one of their own photographs with little risk. Carefully timed intervention and breaking the process down into small steps should ensure a satisfying end product.

Why teach this?

This project can be a very fruitful opportunity for addressing the ICT PoS for Key Stages 1 and 2. At Key Stage 2, it focuses on elements of statement 2a in developing and refining their ideas as they organise and reorganise their images, and also 3a as they share their ideas. The elements of review and evaluation in section 4 and also their reflection on the effectiveness of ICT is an important component of this project. It is possible to address elements of 'Breadth of study' requirement 5b through collaborating with others in their exploration of the tools that the software provides.

The artistic context of this project can add an interesting dimension to the content of QCA ICT Scheme of Work Units 2B: *Creating pictures* and 4B: *Developing images using repeating pattern*s in particular. Using the provisional nature of medium to evaluate and develop art also supports the type of decision making covered in Unit 5A: *Graphical modelling.*

Through manipulating their photographs the children's understanding of visual elements and exploration of colour and pattern which are described in statement 4a of the PoS for Art & Design at Key Stages 1 and 2 is developed. The provisional nature of the medium also encourages the type of investigation of tools and techniques described in section 2 of the Art & Design PoS and fulfils the requirement for the use of digital media in 'Breadth of study' requirement 5c (using a range of processes). The project is very flexible and can fit into a range of themes or enhance Units 1A: *Self-portrait*, 2A: *Picture this!* or 3B: *Investigating pattern* of the QCA Scheme of Work for Art & Design.

As well as supporting creative development, particularly for those pupils who may not have had very positive experiences to date with the development of their own artistic skills, this project has huge potential for fun! As the key learning in both Art & Design and ICT terms is independent of a thematic context, the images can be chosen to respond to the needs and interests of the class. The investigative approach is central from both subject view points. So time for exploration and discussion will pay dividends in learning and also in the assessment opportunities that they afford.

See *Learning ICT in English* Project 7 (*Photo-dramas*) for related activities.

Project Fact Card: Project 6: Sound pictures

Who is it for?

- 7- to 9-year olds (NC Levels 2–3)

What will the children do?

Use a microphone connected to a computer to collect sound files and then combine their sound files with clips from CDs or other sources to create a 'sound picture'.

What do I need to know?

- The main features of Microsoft *Windows Movie Maker*
- How to connect a microphone and record sound files
- The location of sound clips
- How to import and organise sound files
- How to drag and drop sound files to a timeline

What should the children know already?

- How to open and save files
- That graphic objects can be selected, dragged and dropped on the screen
- A familiarity with the standard tape player controls

 ◄◄ | ►► | ► | ■ | ●

What resources will I need?

- Microphone
- *Windows Movie Maker* Software – available with Windows XP

What will the children learn?

- To select skills and techniques to organise, reorganise and communicate ideas
- That ICT can be used to record and manipulate sounds to develop and refine a musical composition
- That sounds can be stored as computer files
- That recorded and live sounds can be combined in a performance

How to challenge the more able

- Include recorded or live performance of musical instruments in their composition
- Encourage evaluation of sound pictures to achieve the sound that is required
- Add captions to finished sound picture

How to support the less able

- Help them to record their sounds and organise the clip files that they require

Why teach this?

- This project focuses on ICT NC KS2 PoS statements 1b, 2a and 3b and also gives an excellent opportunity to discuss the strengths and weaknesses of the use of ICT to aid composition as they review and evaluate their 'sound pictures' (4b, 4c and 5b, 5c).
- The project mirrors the content of QCA ICT Scheme of Work Unit 3B but offers an alternative for older children using *Windows Movie Maker* available with Windows XP.
- The project provides a good opportunity to focus on the Music NC KS2 PoS statements 2b, 3a and 3c as the children choose and organise their own compositions. It responds directly to 'Breadth of study' requirements 5a and 5c and particularly the ICT requirement 5d. Many of the QCA Music units could incorporate some use of this type of sound file manipulation – from Unit 2 to Units 9 and 13.

Sound pictures

What will the children do?

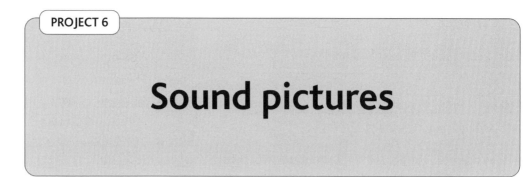

The project builds the children's capability to use ICT to assemble and compose sounds which are then arranged in a sequence to accompany a live performance. The **Sound Recorder** program which is one of the accessories supplied with Windows does enable sound files (.wavs) to be inserted and overlaid to create sound pictures. The very simple appearance of the software, however, makes it hard for children to 'see' their composition. A more visible representation of a musical composition which is built up of several sound files is to be found in *Windows Movie Maker*.

Windows XP operating system includes *Windows Movie Maker* – simple movie-making software which, as well as creating movies, enables sound files to be sequenced and blended along a timeline.

The clear appearance of the software and the ability to drag and drop sound files, trim them to length, blend one with another by overlaying them on the time-line and add your own recorded sounds too, makes the composition of sound pictures accessible to young learners.

Windows Movie Maker screen

Some introductory activities are needed to remind the pupils of previous work involving listening to music that creates pictures or moods or tells a story. The way that themes are introduced and repeated in a variety of types of music will help to set the scene.

Activity 1: Sound sequences

The initial activity needs a collection of sound files to be ready in the software for the children to explore. The sound files appear on the **Collections** screen as large blue notes and the children can hear them by double clicking on them. Once they have explored the sounds available they can begin to assemble or compose a story or sequence by dragging the files down to the timeline. The order of the sounds can be changed by clicking and dragging the separate sound files to new locations. If a sound file lasts for too long, then individual files can be shortened by clicking on the black triangles which appear when a clip is selected on the timeline.

The children should also be shown how to fade one clip over another by selecting it and dragging it over another clip on the timeline. The amount of overlap is represented by a blue bar where the gradient represents the beginning of the following sound.

Activity 2: Recording sounds

Once the children have an appreciation of the software, they can continue to plan and research their sound picture, choosing sound files that they would like to use and identifying new sounds that they need to create. The second activity teaches how the children's own sound files can be created using a microphone attached to the computer. Once the microphone is set up, selecting the microphone icon in *Movie Maker* will open the narration panel in place of the sound clips. The blue playback line needs to be moved to a clear space on the **Audio/Music** timeline and the **Start Narration** button clicked when you are ready to record. When **Stop Narration** is pressed the new sound file will be saved and it can be repositioned on the timeline by clicking and dragging in the same way that other files are moved. To return to the sound file collections click **Done**.

The children can then combine their recorded sound files with others to create their sound picture.

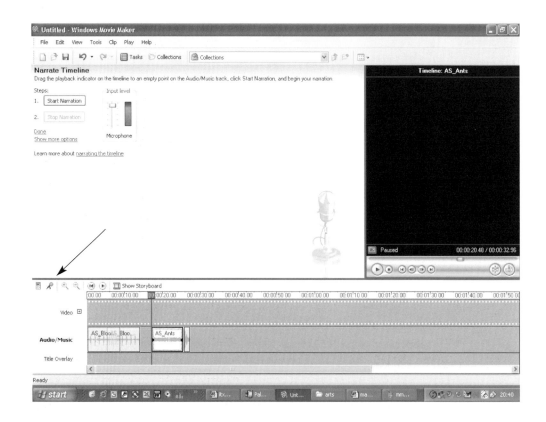

What should the children know already?

How to open and save files

This project should extend children's understanding of what files are and how computers can process information in a variety of formats once the information is in a digital form. As the sound pictures are made up of a number of separate files an ability to locate them is helpful. Files can be transferred to the **Collections** panel in *Movie Maker* by dragging and dropping from another directory or folder window.

That graphic objects can be selected, dragged and dropped on the screen

Understanding that moving icons from one part of a window to another is a way of giving instructions to the computer is helpful to this task.

A familiarity with the standard tape player controls

The buttons above the timeline use the rewind and play conventions of tape players.

What do I need to know?

The main features of *Windows Movie Maker*

Movie Maker was not designed for this type of 'sound picture' creation so there are sections of the software which deal with video and captioning that are not necessary for this task – although it is possible to extend the project by adding images and captions to complement the sound. When you first open the software, therefore, you will need to click on the **Show Timeline** button to see the audio track. As with any new software, experimenting with the task that you are going to set the children is vital. When playing back, the progress through the sound files is represented graphically by a blue line. To play one part of the track click and drag the blue line to the place that you want to hear and press the play button.

How to connect a microphone and record sound files

Nearly all computers have a microphone socket somewhere and many will operate without any intervention. If you experience difficulties, you can make adjustments in the **'Sound and Audio Devices' Control Panel** available from the **Start** menu.

Before you can begin capturing a new sound file in *Movie Maker*:

- the blue line playback indicator on the timeline must be at a position where the Audio/Music track is empty; and
- you must be in the timeline view.

Clicking on **Start Narration** will capture sound via the microphone and create a new sound file.

When the sound has been recorded click **Stop Narration**. The sound that you have captured is saved as a Windows Media Audio file with a .wma file name extension. By default, the audio narration file is saved in the **Narration** folder under **My Videos** on your hard disk. It can now be manipulated in the same way as the other files.

Checking the microphone

- The coloured recording meter in the **Narrate Timeline** panel indicates the input level of the microphone. The sound level can be adjusted by the slider on the left. If the recording meter is not responding, first check that the microphone is plugged in to the correct socket and then check the control panel. The **Control Panel** is available from the **Start** menu. Select the **Sound and Audio Devices** icon and double click to open the controls.

- Selecting the **Audio** tab at the top of the **Properties** window will display the **'Sound recording' Volume** button.
- Ensure that the microphone volume is high enough.

The location of sound clips

Even if you are planning to spend a considerable amount of time creating original sound files for this project, the initial activity introducing the children to the capability of the software will need a number of sound files. There will be some sound effects on your computer and possibly music files. A search will locate what is available. *Movie Maker* will also import music files, but you need to be particularly careful of copyright and need to own a recording of commercially available music before you use it in this way. Sound files can also be purchased on CD-ROM or searched for and located on the internet. Organising sound clips into folders or directories will help.

How to import and organise sound files

In order to import clips it is possible to drag and drop individual files or to select several by dragging a box around them in the directory window or holding down **Shift** on the keyboard while you click on a number of files. Once they are selected click on one and drag them to the *Movie Maker* window. Alternatively, through the **File** menu in *Movie Maker*, **Import into Collections. . .** can be selected and the directory where the clips are saved located. Several files can be imported simultaneously by dragging a box around them in the **Import File** dialogue box and selecting **Import**.

How to drag and drop sound files to a timeline

Once the sound files are visible in the **Collections** window, the composing and arranging can begin. Sounds can be placed in order or inserted between other sounds by clicking and dragging them. Sound clips can be shortened by clicking on one of the triangles on the end of a selected clip and dragging towards the centre of the clip. If an overlap is required between sounds, dragging one file over the previous one will make the two sound cross-fade when played.

What will the children learn?

To select skills and techniques to organise, reorganise and communicate ideas

At the heart of this project is a creative endeavour. The steps along the way are designed to enable the children to compose their own sound picture or story by assembling phrases and collected sounds to communicate a feeling, mood or event.

That ICT can be used to record and manipulate sounds to develop and refine a musical composition

Many of the processes and skills that the children will employ in this project are common to recording professionals. This software puts a very powerful and empowering tool in the hands of young learners.

That sounds can be stored as computer files

Although any children with knowledge of MP3 players will already be aware to some extent of the existence of digital music, this project importantly includes the creation as well as the manipulation and storage of sound files.

That recorded and live sounds can be combined in a performance

Children should be encouraged to add to their sound pictures with live perform-ance using voices or instruments. By discussing and evaluating recorded and live components both their understanding of layers of sound and their evaluation of their ICT use will benefit.

Challenging the more able and supporting the less able: modifying the project for older and younger pupils

As the project only uses a fraction of the capability of this software it is relatively easy to add challenges for more able pupils. The final sound pictures can be just one track of a more complex live performance using musical instruments or just one element in a cross-curricular integrated arts project. Both still images and video can be imported to *Movie Maker* to make a slide show or animation of chil-dren's artwork. It is also possible to add captions to the finished sound picture so that poetry or creative writing could be included too.

Encouraging and motivating children is always easier when they are pursuing their own ideas in a creative way. Continue to question the more able children to ensure that they achieve the finished sound that they set out to produce.

Children who may struggle with aspects of this project can still produce an orig-inal result by choosing from a limited range of ready-made sound files. By working with an adult, a small group can record a file which could be imported and shared by all.

Why teach this?

If managed properly the children get a huge sense of ownership and enjoyment from this type of project. The process of creating and evaluating compositions of sound using ICT is valuable for their development in both Music and ICT. The activities in the project provide an important addition to children's understanding of the way that information – in this case sound – is prepared so that it can be manipulated and processed by the computer. The main National Curriculum aspects are the development, exchanging and sharing of ideas in ICT and the creating and developing of musical ideas. In particular the project focuses on ICT National Curriculum KS2 PoS statements 2a, in the development and refining of their ideas as they organise sounds, and 3b, through evaluating their compositions taking into account the purposes and needs of the audience. The project also gives an excellent opportunity to discuss the strengths and weaknesses of the use of ICT to aid composition as children review and evaluate their 'sound pictures' (4b and 4c) and it contributes to the 'Breadth of study' as they collaboratively explore tools and consider their use of ICT (5b and 5c).

The project provides a good opportunity to focus on the Music NC KS2 PoS statements 2b, as the children choose and organise their own compositions, and 3a and 3c, as they develop their ability to appraise and improve their work through analysing and comparing sounds. It responds directly to 'Breadth of study' requirements 5a, in the integration of composing and appraising, and 5c, working in groups or individually. The ICT requirement 5d is addressed through this type of work.

Listening to a range of music which uses themes to communicate events or represents characters would enhance the children's experience. Film and television soundtracks which can be analysed with and without the accompanying pictures make good material to provide inspiration for this project. As the children review and evaluate the ideas behind their 'sound pictures' there is an excellent opportunity to discuss the strengths and weaknesses of the use of ICT as an aid to musical composition.

The project mirrors the content of QCA ICT Scheme of Work Unit 3B: *Manipulating sound* but offers an alternative for older children. Many of the QCA Music units could incorporate some use of this type of sound file manipulation – from Unit 2: *Sounds interesting – Exploring sounds* to Unit 9: *Animal magic – Exploring descriptive sounds* and Unit 13: *Painting with sound – Exploring sound colours.*

See *Learning ICT in English* Project 4 (*Working with audio*) and *Humanities* Project 9 (*A video of a visit to a place of worship*) for related activities.

Project Fact Card: Project 7: Using a spreadsheet model

Who is it for?

- 7- to 9-year olds (NC Levels 2–3)

What will the children do?

Use and adapt a class-produced spreadsheet to model possible ingredients for a healthy sandwich to meet the needs of a friend. The spreadsheet model will help the children make choices to inform their designing and making. Using nutritional information from food labels, formulae will be constructed with the aid of the teacher to calculate the consequences of their choices.

What do I need to know?

- Basic spreadsheet functions; what a cell is and how to identify it
- How to enter information into a spreadsheet
- How to construct formulae
- That cells can be formatted to show a specified number of decimal places
- How to use **AutoSum**
- How to format cells
- How to lock cells so that the information they contain can be protected

What should the children know already?

- Basic mathematical operations: add, subtract, divide, multiply
- How to position the cursor and enter information
- That computers can perform calculations

What resources will I need?

- Spreadsheet software such as *Microsoft Excel* or BlackCat *NumberBox 2*
- Food and nutritional information labels

What will the children learn?

- That organising information can help to answer questions
- To explore the effect of changing the variables in a model and use them to make and test predictions
- That computer models enable alternatives to be explored and decisions to be evaluated
- How to select a cell and add information to a spreadsheet

How to challenge the more able

- Add a new row to the spreadsheet
- Gather the nutritional information from a new product label
- Add another column to the spreadsheet (e.g. fibre or vitamin content for the ingredients that they have chosen) and research to provide information for the formula

How to support the less able

- Construct a simplified spreadsheet with fewer ingredients and/or nutritional information

Why teach this?

- The project is targeted on ICT NC KS2 PoS statements 1b, 2a and 2c and also gives an excellent opportunity to discuss the use of ICT for modelling as required by statements 4b and 4c of the 'Reviewing, modifying and evaluating work as it progresses' strand of the ICT PoS.
- Although this project introduces spreadsheets earlier than the QCA Scheme of Work for ICT suggests, the collaborative nature of the task and emphasis on use rather than construction of the model makes it possible to use with younger children. It supports Units 3D and 4E and prepares children for Unit 6B.
- The project makes appropriate use of ICT to support teaching and learning in National Curriculum D&T, particularly in the areas of 'Developing, planning and communicating ideas' (1a–c) and 'Evaluating processes and products' (3c). It is also a valuable addition to QCA D&T Scheme of Work Unit 3B.

Using a spreadsheet model

What will the children do?

The main purpose of this project is to introduce the children to ways in which spreadsheets can be used to model real situations as part of a design unit similar to QCA D&T Scheme of Work Unit 3B: *Sandwich snacks*. While children will not be expected to create their own spreadsheet models until they reach Year 5 or Year 6, teachers can use *MS Excel* to create information-gathering and modelling packages for much younger children. The inclusion of an ICT activity of this kind in D&T teaching encourages children to make decisions and evaluate them as they design. As the spreadsheet software is performing the calculations for them, the children are able to focus on their decisions and the consequences of them. One key opportunity with any food topic is to explore issues relating to healthy eating and the consequences of poor diet. The opportunity afforded by ICT in this instance to model the consequent nutritional content of their sandwich designs will give rise to productive discussions.

Nutritional information from packaging

It is important that the spreadsheet that you design is based on the ingredients that the children wish to use. As part of a good design unit the children will have had experience of evaluating other foods and undertaken practical tasks to develop their skills with the tools and techniques. By undertaking an exercise in the early part of the unit where the children are asked to list possible ingredients that they are going to consider using, based on the needs of the consumer and the design brief, it is possible for the teacher to construct the framework of the spreadsheet model that the children are going to use. All the information that is required for the spreadsheet can be found written on the packaging of the ingredients.

Activity 1: Exploring a model

Sandwich Designer Spreadsheet Model

Ingredient	How much (g)	Sugar (g)	Fat (g)	Fibre (g)
Ryvita	22	0.7	0.4	3.8
Olivio	2	0.0	1.2	0.0
Peanut butter	6	0.9	3.0	0.3
Totals	30	1.5	4.6	4.2

An example spreadsheet constructed in Excel

Introduce the children to the spreadsheet model and use it to analyse the nutritional content of a sandwich that you have chosen. Make sure the children are clear about where to enter the quantities and where to read the information. As ICT is being used as a tool to inform judgements about design decisions, the focus of this activity does not need to become too involved with the ICT at this stage. Following the introduction with a simple model, the spreadsheet can be extended to include the range of ingredients that the children wish to use.

Activity 2: Design decisions

The children will use the spreadsheet to evaluate the content of several options that they have designed. Challenges can be set at this stage to differentiate the work. For example, if the children are designing their sandwich for a specific person, then the preferences and needs for low salt or low sugar options could be added to the design brief. By the end of the exercise the children should be able to

take into account the contents of their designs as well as the likes and dislikes of the consumer, or other requirements of the brief. It is important at this stage to encourage the children to 'model' effectively using the spreadsheet. If, for example, they discover when entering the ingredients for one of their ideas that the sugar content is too high, suggest that they alter the balance of the ingredients to try to reduce the sugar and still keep the essence of the design. At the heart of the modelling process should be a desire to answer the question 'What would happen if . . .?' Trying out alternatives using the spreadsheet should help them to make decisions about their designs without wasting ingredients.

Activity 3: Evaluating the model

If the children are to develop their knowledge and understanding of the ways in which they can use ICT, then a discussion that explores the role that the spreadsheet has played in their designing is necessary. The concept of a function machine will be familiar to the children and a lesson which shows the formulae that are in the spreadsheet will help to sow the seeds for their own spreadsheets and an understanding of variables that will come later. Some children may be keen to extend the spreadsheet (see 'Challenging the more able' below).

What should the children know already?

That computers can perform calculations

Building on the children's previous experience of ICT by highlighting the similar features of new software will help to develop their understanding. These tasks can act as an introduction to spreadsheets and be undertaken with very little previous experience if appropriately paced. While it is possible for children to use a spreadsheet model with very little understanding of how it works, valuable opportunities to see basic mathematical operations being used for a purpose are afforded through the activities.

How to position the cursor and enter information

Most children will be familiar with the need to position the cursor before typing and the selection of cells is very similar.

Basic mathematical operations: add, subtract, divide, multiply

They should also be aware that computers can perform calculations or undertake tasks very quickly. For those children working at NC Level 2 they will have used ICT to explore what happens in adventures or different situations. As they undertake these activities there should be opportunities for us to form judgements about their ability to make appropriate choices when using this model to help them solve their design problems.

What do I need to know?

Basic spreadsheet functions; what a cell is and how to identify it

Spreadsheets were developed as an accountants' tool. The task of adding columns and rows of figures has been with us for centuries. The huge advance that computer-based spreadsheets have brought to the task is owed to the provisional nature of the data and the ability to construct sheets that contain formulae that enable sums to be recalculated when you go back and change one of the numbers. For example, if we take a simple calculation such as $5 + 2 = 7$, we could enter it in a spreadsheet like this:

	A	B	C	D	E
1	5	+	2	=	= 5 + 2

When we press enter in cell E1 the spreadsheet will automatically calculate the contents $[= 5 + 2]$ and enter 7 in the cell. Although there is some use in doing one-off calculations of this sort, the real power comes when you construct a formula that says something like 'take whatever is in cell A1 and add it to whatever is in C2 and put the answer here' and enter that formula into cell E1. The ability to recalculate using formulae is at the heart of a spreadsheet model as it enables us to change elements of the equation and answer the question 'What happens if . . .?'

How to enter information into a spreadsheet

To design your spreadsheet model start by constructing the table. Click in cell A3 – leave a couple of rows for a title – and begin to type. You will see the text appear in the cell and also on the line at the top of the spreadsheet that is called the formula bar.

Pressing **Enter** will insert your text in the cell and normally move down to select the next cell. You can also use the mouse to select a cell of your choice. Notice that the units have been put in the column title. Because we want the spreadsheet to calculate the numbers that we are going to put in the cells, it is important that we do not enter units with the numbers as it will make the calculation impossible. Once the column headings and the ingredients have been entered you are ready to add the formulae.

	A	B	C	D	E
1	Ingredient	How much (g)	Sugar (g)	Fat (g)	Fibre (g)
2	Ryvita				
3	Olivio				
4	Peanut butter				

How to construct formulae

The idea is that all the children need to do is decide how much of an ingredient they wish to use and enter the quantity in the 'How much' column alongside the name of the ingredient. What the spreadsheet will then do is calculate how much sugar, fat and fibre are contained in the quantity that the child has selected. All food wrappers must indicate the quantity of sugar, fat and fibre in 100 g. By dividing those quantities by 100 we are able to arrive at the amount contained in 1 g. So for Ryvita, for example, the values on the packet for 100 g are:

Sugar 3 g
Fat 1.6 g
Fibre 17.4 g

Therefore we need to multiply the number of grams of Ryvita that a child chooses by

.03 to obtain the amount of sugar that it contains
.016 to obtain the amount of fat that it contains
.174 to obtain the amount of fibre that it contains

To enter the formula click in the cell where you want the answer to appear and type:

	A	B	C	D	E
1	Ingredient	How much (g)	Sugar (g)	Fat (g)	Fibre (g)
2	Ryvita		= B4 * 0.03	= B4 * 0.016	= B4 * 0.174
3	Olivio				
4	Peanut butter				

Each time you press enter the cell will record 0.0 as there is nothing in cell B4 yet, but when you select the cell again you will be able to see the formula on the formula bar.

Test your formulae by entering a number in cell B4 and pressing **Enter**. The values in cells C4, D4 and E4 should all change. Try replacing the number in cell B4 with another value and watch your model recalculate as you press **Enter**.

Using the nutritional information labels from the other ingredients, complete the formulae.

That cells can be formatted to show a specified number of decimal places

It is likely that you will end up with values in your spreadsheet that record too many decimal places for the children's understanding. By selecting the cells concerned and clicking on the 'decrease decimal' button on the toolbar the number of decimal places visible can be adjusted to match the children's understanding.

How to use AutoSum

Once all of the formulae have been entered for the ingredients that the children have suggested the final row which displays the totals can be added. As well as creating formulae by writing the equations there are many functions which are available in *Excel*. The quickest way to total a column or row is to click in the cell at the end where you want the total to be and click the **AutoSum** button on the toolbar. $\boxed{\Sigma}$

The formula **=SUM(...)** will automatically be inserted and the software will usually insert the most likely range of cells into the bracket. In the example on the right it has correctly inserted **D4:D11** and pressing **Enter** will enter the result of the calculation in the cell. If clicking **AutoSum** fails to identify the cells that you require, the correct cells can be inserted in the formula either by clicking and dragging across them or by typing the cell addresses in the formula bar. Once you have successfully added the total to one column you can quickly copy the formula to the other columns by selecting the cell containing the formula that you have just created once more. Then position the cursor over the bottom right-hand corner of the cell until it turns into a bold black cross like this:

g)	Sugar (g)	Fat (
	0.0	0.0
	0.0	1.2
	0.9	3.0
	0.0	0.1
	0.0	0.0
	0.0	0.0
	7.4	5.0
	0.2	11.9

=SUM(D4:D11)

SUM(**number1**, [number2], ...)

Then click and drag right across the cells under the other columns. The formula will be copied relatively – that is, it will read = **SUM(E4:E11)** in column E and = **SUM(F4:F11)** in column F and so the appropriate totals will be entered.

How to format cells

The appearance of the spreadsheet can help to communicate the information and the different types of cell to the children. It is worth considering whether or not you plan to use the sheet as a class resource on an interactive whiteboard, as decisions about font size and layout can ensure that the information is legible and that the whole sheet can be viewed without having to scroll across or down.

Size of cells

The size of the cells can be adjusted for height and width by moving the cursor to a dividing line between the row or column name where it will change into a double pointed arrow like this:

	A	B	C	D	E
1					
2					

Dragging the line will change the width of the column. If a series of columns all need to be the same width, select the columns first by clicking and dragging across the column headings B, C, D, etc. and then click and drag one of the dividing lines. All the columns will become the new width. The same procedure applies to row height.

Font and fill colour

The font appearance and size can be altered by selecting cells and using the toolbar buttons. Using the paintpot fill tool also enables the background colour of individual cells or blocks of cells to be coloured. It is useful to identify the colour of the cells where children are to add the quantities of ingredients, for example, and use a different colour for the totals. It is also possible to use the borders tool to make the grid lines visible or to remove them.

How to lock cells so that the information they contain can be protected

It is useful to be able to protect a sheet of this sort especially if you want children to be able to use it independently. It is possible to lock the cells containing the formulae so that they cannot be overwritten but keep open other cells for children to enter the quantities that they wish. *Excel* provides a two-stage protection process. First of all you need to identify the cells that you do want children to be able to enter information in and those that you want protected. In this case it is only the cells in the 'How much' column that we want to leave unlocked. So if we first of all select those cells and then click on the **Format** menu and choose **Cells...**, the dialogue box shown on page 74 will appear. Select the **Protection** tab at the top of the box and the option to lock or hide the selected cells will become available. The **Locked** option is usually ticked, so for our 'How much' cells we need to click on the tick to remove it. Once we click on **OK** to close the dialogue box the first part of the protection process is complete.

The second part of the process involves protecting the sheet. You will be asked to supply a password to protect the sheet. If you leave the password blank, then the sheet will be protected but can be unlocked by anyone.

Sandwich Designer: Spreadsheet Model

Ingredient	How much (g)
Ryvita	0
Olivio	2
Peanut butter	6
Tuna	22
Mango Chutney	
Golden Syrup	
White Bread	50
Mayonnaise	15
Totals	**95**

Format Cells

Number | Alignment | Font | Border | Patterns | Protection

☑ Locked
☐ Hidden

Locking cells or hiding formulas has no effect unless the worksheet is protected. To protect the worksheet, choose Protection from the Tools menu, and then choose Protect Sheet. A password is optional.

OK Cancel

If you do select a password – remember it!

To protect the sheet:

1. Select **Protection > Protect Sheet. . .** from the **Tools** menu.
2. Either choose and enter a password and click **OK** or just click **OK**.

In order to edit a protected sheet, selecting **Protection** from the **Tools** menu will reveal **Unprotect Sheet. . .** in the sub-menu. If you have not selected a password, the sheet will be unlocked for editing by selecting this option. If you did enter a password, you will be prompted to enter it before the sheet can be unlocked.

Tools Data Window Help

ABC	Spelling...	F7
	Error Checking...	
	Speech	▶
	Share Workbook...	
	Track Changes	▶
	Compare and Merge Workbooks...	
	Protection	▶
	Online Collaboration	▶
	Goal Seek...	
	Scenarios...	

🔒 Protect Sheet...
Allow Users to Edit Ranges...
Protect Workbook...
Protect and Share Workbook...

What will the children learn?

That organising information can help to answer questions

The information required for this task is freely available on the packaging of nearly all foodstuffs that you can buy. By spending the time to process that information and bring it together, comparisons between ingredients can be made quickly.

To explore the effect of changing the variables in a model and use them to make and test predictions

Sometimes free exploration of this type of model can fuel the children's imagination as any combination can be modelled without waste. In this part of the design process they can be encouraged to be innovative. Good questioning will challenge the children to balance conflicting demands of the brief; can they, for example, increase the amount of fibre and reduce the sugar content? Drawing out predictions from the children will help develop their strategies for mental arithmetic with the feedback coming from the model by inviting them to 'try it and see!'

That computer models enable alternatives to be explored and decisions to be evaluated

The essential purpose of any model is to evaluate the consequences of your actions and eliminate problems in a small-scale or less costly environment before attempting the real thing. What the computer will not do is evaluate the aesthetic, structural or other sensory aspects of the chosen ingredients, but an important part of design is for children to learn to consider a variety of consequences of the choices that they make. Part of the evaluation will teach children to read the ingredients labels and contribute to their consumer education. The design curriculum also includes assessing risks and children may decide to label their sandwich using the information from the spreadsheet, or even include a warning!

How to select a cell and add information to a spreadsheet

The key ICT learning in this project is to enable the children to demonstrate that they can make appropriate choices when using ICT-based models or simulations to help them find things out and solve problems. There are also useful opportunities for the children to describe their use of ICT and its use outside school. The actual hands-on development of skills could be limited to the selection of the appropriate cell on the spreadsheet, typing the number of their choice and pressing **Enter**. With some children it may be advantageous to deconstruct the model with them, to show how it works, and prepare them for the construction of their own spreadsheet models later on.

Challenging the more able and supporting the less able: modifying the project for older and younger pupils

There are plenty of opportunities to stretch able children with this type of divergent design task. In design terms the children can be encouraged to set themselves challenging requirements for their sandwiches. To develop ICT capability any of the tasks undertaken by the teacher to create the spreadsheet can be taught to the children. It is highly likely that, irrespective of the detail of initial discussions, a new ingredient will be thought of and will need to be added to the spreadsheet. The children and teacher can collaborate in varying degrees in order to extend the

spreadsheet. Some children could gather the nutritional information from a new product label and help to create the formulae required. It is also possible to contrive, if it does not arise naturally, for another column to be added to the spreadsheet (e.g. salt or vitamin content). That would necessitate research into all the ingredients that they have chosen to provide information for the formulae.

It is important to recognise the density of information in any table, especially one which changes in a dynamic way. Some children may find the spreadsheet confusing and need a simplified spreadsheet with fewer ingredients and/or nutritional information. A key advantage of ICT in this respect is the speed with which the teacher is able to copy the spreadsheet several times and quickly delete rows or columns to produce several differentiated resources. *Excel* is very good at adjusting formulae to compensate for deleted rows to ensure that the sheet will still work.

Why teach this?

The project is designed to address ICT NC KS2 PoS statements 1b, 2a and 2c and also gives an excellent opportunity to discuss the use of ICT for modelling as required by statements 4b and 4c of the 'Reviewing, modifying and evaluating work as it progresses' strand of the ICT PoS. Discussion of the value of the model and how it has helped with this task is important for children to develop their understanding of spreadsheets, in particular, and ICT more widely. Draw out the connections with other types of computer-based model – particularly, in the context of design and technology, how they can try things out graphically with drawing software. Videos or demonstrations of the ways more complex models are used to make decisions in society by engineers, meteorologists or even economists can also make a valuable contribution.

Although this project introduces spreadsheets earlier than the QCA Scheme of Work for ICT suggests, the collaborative nature of the task and emphasis on use rather than construction of the model makes it possible to use with younger children. It can be done at a very simple level and yet, with careful discussion and explanation, will have an impact on children's understanding. It supports Units 3D: *Exploring simulations* and 4E: *Modelling effects on screen* and prepares children for Unit 6B: *Spreadsheet modelling.*

The project makes appropriate use of ICT to support teaching and learning in National Curriculum D&T, particularly in the area of 'Developing, planning and communicating ideas' (1a–c) and also 'Evaluating processes and products' (3c). It is also a valuable addition to QCA D&T Unit 3B: *Sandwich snacks* – particularly at Level 3 when we need opportunities for the children to show that they think ahead about the order of their work, choosing appropriate materials. They also need to identify where evaluation of their products has led to improvements. These spreadsheet activities will help to generate evidence of their ability in this area.

See *Learning ICT in the Humanities* Project 6 (*Using a database to analyse census data*), *Maths* Project 9 (*Patterns and spreadsheets*) and *Science* Project 4 (*Branching databases*) for related activities.

Project Fact Card: Project 8: LOGO animation

Who is it for?

- 9- to 11-year-olds (NC Levels 3–5)

What will the children do?

Create an animated scene using LOGO programming, graphic drawing and paint tools. The scene can be created using the tools contained with programs such as *MicroWorlds* or separately using *Paint* and imported as a background to Roamer World or other LOGO programs.

What should the children know already?

- Basic commands to control Roamer or a screen turtle
- How to select and use draw and paint tools
- How to save and recall files

What do I need to know?

- How to use basic draw and paint tools
- How to add and control multiple turtles
- How to edit and apply a shape to a turtle
- The principles of LOGO procedure writing
- How to access **Help** in your LOGO program
- How to add and program buttons
- How to support and challenge children to solve problems

What resources will I need?

- Paint software and LOGO software such as *RoamerWorld* (Valiant Technology) or *BlackCat Logo*
 Or
- *MicroWorlds* from LCSI

What will the children learn?

- How to create and control multiple turtle shapes
- That ICT can be used to develop images
- That ICT makes it easy to explore alternatives
- To write repeating procedures to produce a desired outcome
- That procedures can call other procedures

How to challenge the more able

- Set additional challenges – although, once motivated, children will set their own
- Introduce conditional statements to procedure writing

How to support the less able

- Create some basic procedures that children can call up
- Prepare imported images or backgrounds that children can select
- Use drama and off-screen drawing to help to sequence instructions

Why teach this?

- The project aims to teach ICT NC KS2 PoS statements 2a–c, 3a and 3b and also gives an excellent opportunity to explore ICT tools described in 'Breadth of study' requirement 5b. Section 4 of the PoS, 'Reviewing, modifying and evaluating work as it progresses', is central to this type of creative problem-solving activity.
- The project complements and extends the Roamer and Turtle units (2D and 4E) in the QCA ICT Scheme of Work. It offers a creative context for developing similar outcomes as Units 5E and 6C.
- This animation project can be approached through an Art & Design context, developing the children's creativity and imagination with the increasing complexity demanded of upper Key Stage 2. It provides a good opportunity to explore accessible digital media and address the ICT use outlined in Art & Design 'Breadth of study' requirement 5c.

LOGO animation

What will the children do?

Making pictures come to life fascinates children of all ages. Using *LOGO MicroWorlds* software enables a fertile synthesis to forge cross-curricular learning and produce creative maths or technological art. As well as the commands available in all LOGO programs, *MicroWorlds* software contains tools to enable children to paint backgrounds to create their own environment (or environments, as a project can have several pages) and a variety of turtle shapes that can be edited. Using a combination of these tools, children can create scenes with moving elements like the one below.

In the example, the sky, sea, sand, rock and three reeds on the right have been drawn using paint tools available in the software. The galleon, shoal of fish and reed on the left are all 'turtles'. The fish shape and galleon are shapes which come

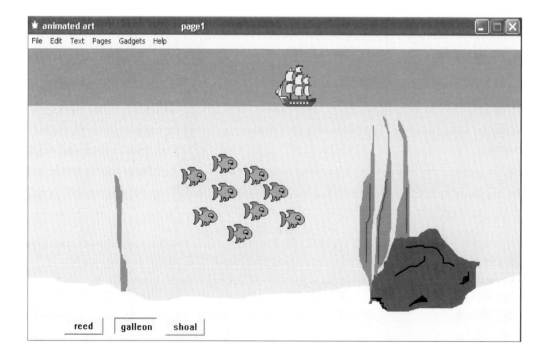

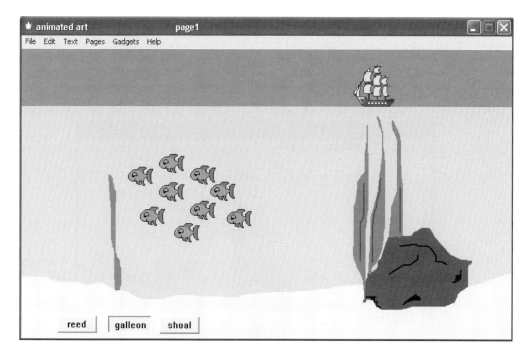

Animated screens produced using MicroWorlds *(screenshots reproduced courtesy of LCSI)*

as part of the software. The reed has been drawn using the turtle editor part of the program. The buttons at the bottom of the screen control the animation; the reed moves from side to side, the shoal of fish move together to the left and then to the right and the galleon creeps along the horizon.

There are three strands to a project of this sort: the design of the fixed parts of the background; the design of the turtle shapes; and the control of the movement. In order for the children to understand the purpose of the activities and the scope of the choices that they can make when designing, all three need to develop together.

Activity 1: Introducing *MicroWorlds*

You may wish to begin by demonstrating an example but be careful not to stifle the creative possibilities of the project by limiting the children's choices through the example that you show them. The initial activity will depend on the children's previous experiences. They will need to be able to add multiple turtles to the screen and learn how to apply a shape to each turtle initially using the pre-defined designs. They should also be reminded of the LOGO commands that they have used previously to make the different turtles move. If this is the first experience of multiple turtles, the children will need to be introduced to the **talkto** or **tto** command to identify which turtle they wish to move.

Activity 2: Designing an environment

The second activity will need to build on the children's previous experience with draw and paint software. There are almost limitless contexts for this activity;

landscapes can be created or portraits or abstract designs. It is also possible to import images and use the stamp tool to create repeating patterns.

Activity 3: Creating turtles

Creating turtles, pixel by pixel, in MicroWorlds *from LCSI*

The turtle shapes are created or modified using a pixel editor which enables shapes to be changed dot (pixel) by dot. Working on this scale may be new to the children and they will need to practise modifying existing designs and creating their own. By copying a design and flipping it the children can also be taught how to use the **setshape** command to change a turtle's shape – the shoal of fish in the example above are made to appear to turn in this way.

Activity 4: Building procedures

Up until this point the children can work with direct commands typed into the command dialogue box called the 'Command Center' in *MicroWorlds*. To enable constructive learning – where children are able to enter commands, evaluate their effect by the response of the software and modify and improve them – the children need to build procedures. This activity needs to teach the children how to create procedures on the 'Procedures' pages of the software and then return to their project page to test them out. Initially procedures can be called up by typing the procedure name in the command centre. The children will also be taught to create buttons which can call up their procedures. There are some key LOGO commands which help with this type of animated picture that the children may not have used before which need to be introduced at this stage (see 'What do I need to know?', below).

As a creative activity children will need time to develop their own ideas. If their experimentation has been saved during these first four activities, then they can

draw on procedures and designs as they build their projects either alongside the activities or once they have been completed. You will need to encourage the children to use the **Help** facility and be ready to teach them new commands as they become necessary in order to complete their individual projects (see 'Challenging the more able . . .', below).

What should the children know already?

Basic commands to control Roamer or a screen turtle

The commands that the children may have used to control Roamer can be used as a starting point if their only experience of control has been using this type of programmable toy. Ideally they will have used a version of LOGO or *RoamerWorld* which will have introduced them to an executable set of instructions or procedure.

How to select and use draw and paint tools

Pure versions of LOGO require all graphics to be drawn by the turtle. *MicroWorlds* has a paint facility which will appear familiar to anyone who has used a computer paint package. It is not as sophisticated as some paint software but it is integrated with the turtle graphics part of the program, enabling instructions to be associated with particular colours, for example, so that turtles will change size when they pass over. Basic shape, brush and fill tools are available to create the scene.

How to save and recall files

Developing these animated pictures should be a creative process for the children where ideas evolve and problems are created as the children seek to exert control over the medium to achieve the desired effect. It will be necessary to save procedures and return to them on several occasions to edit and debug, giving a good opportunity to revisit the value and purpose of saving and to reinforce the provisional nature of digital information.

What do I need to know?

How to use basic draw and paint tools

For those of us who came to ICT later in life it is often the paint and draw software with which we feel less familiar. There is no substitute for some personal investigation and exploration of the tools available in a piece of software – set yourself a challenge; that way you are more likely to seek out the limitations of the software.

The paint tools are revealed in *MicroWorlds* when you click the brush icon to the left of the command box. By selecting a tool and a colour from the palette it is possible to make marks on the graphics page by clicking and dragging the mouse.

The button between the line thickness tool and the other tools is the undo facility which undoes the last command. The scroll bar to the right of the colour palette can be used to alter the tint or hue of the colours.

How to add and control multiple turtles

MicroWorlds, in common with many LOGO programs, allows multiple turtles to be placed on the screen and controlled. A new turtle is added by selecting the hatching turtle icon and clicking on the screen.

How to edit and apply a shape to a turtle

A new turtle added to the screen will have the traditional turtle shape. It is possible to make the turtle adopt a different shape using the pre-defined shapes that come with the program or creating your own. Selecting the middle dog icon reveals the turtle shapes. The scroll bar on the right-hand side of the shapes palette can be used to reveal more choices.

In order to change the shape of the turtle, first select the shape of your choice by clicking on it and then click on the turtle on the screen.

It is important to note that although you may turn the turtle, the shape will always face the same direction. So, in order to achieve the effect outlined in the seascape example that started this project, a right-facing fish shape was created. The empty spaces signified by the eight dots to the right end of the shape palette above are provided for new shapes to be created or existing ones to be copied and modified. The process for creating the other fish shape is as follows:

1. Select the existing fish shape.
2. Select **Copy** from the **Edit** menu.
3. Click in one of the eight empty spaces.
4. Select **Paste** from the **Edit** menu.
5. Click on the new fish shape that is pasted and the shape editor opens.

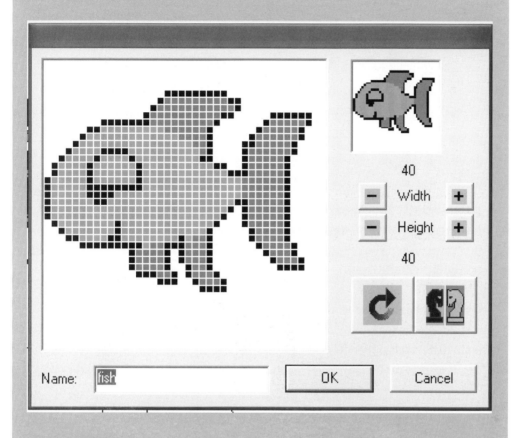

Name: fish OK Cancel

6. Click the icon with the two chess pieces on it.
7. Name the new shape 'fish2' and click **OK**.

You will notice that as the shape editor opens, the paint tools also appear making it possible for shapes to be edited or created dot by dot. Once a shape is created and named it can be applied to a turtle or used in a procedure.

The principles of LOGO procedure writing

It is possible to give commands to turtles in several ways. Commands can be written in the command window by clicking the top icon of the three to the left of the window and typing. These commands, however, once executed, are not saved. It is also possible

to 'open' the turtle and write commands which will be carried out each time it is clicked. The turtle instruction box is opened by either right clicking on a turtle or by selecting the 'eye' or 'hatching turtle' tool and left clicking on the turtle that you wish to control. By selecting **Many Times** the turtle will carry out the instructions continuously.

```
Name:        t2
Instruction: 
Do It:   ⊙ Once
         ○ Many Times        [  OK  ]    [ Cancel ]
```

If one of the key purposes of this project is for children to develop procedures to control the animation in their picture, it is preferable for them to define sets of instructions using the 'Procedures' page which can be accessed by selecting **Procedures** from the **Pages** menu. This is where new words can be defined in the traditional LOGO way. The key advantage is that the commands that the children develop can be saved and revisited and improved once the feedback from the behaviour of the turtle has been evaluated. It is this process that makes the project such a valuable learning experience.

Let us use the procedure that controls the shoal of fish to look at some principles:

⊙ **to shoal** – Using 'to' indicates that a procedure is being written and the word 'shoal' is being defined. That means that all that comes between this line and 'end' will be carried out every time the command 'shoal' is given.

⊙ **talkto [t2 t3 t4 t5 t6 t7 t8 t9 t10]** – The 'talkto' command that can be abbreviated as 'tto' indicates which turtles have to obey all that follows.

⊙ **pu** – 'pu' stands for 'pen up' just to make sure that the fish do not draw lines behind them – can you guess what 'pd' stands for?

⊙ **setsh "fish** – This makes sure that our fish become left-facing fish for the first part of the procedure. 'setsh' stands for 'set shape' and the " tells the program that what follows is a name. Just moving the pointer over the turtle shapes in the shape palette will display the name of each shape.

⊙ **seth 270** – 'seth' stands for 'set heading' and uses compass bearings where up the screen is North or 0. So, heading 270 ensures that our turtles go left or west.

⊙ **glide 200 1** – The 'glide' command instructs the turtles to move a distance of 200; the second input tells the turtle how fast it will glide.

⊙ **setsh "fish2** – This command changes the shape of the fish into the right-facing shape that we edited and named 'fish2' above.

⊙ **seth 90** – Can you work this one out?

⊙ **glide 200 1** – and this one?

⊙ **end** – The 'end' command indicates that the procedure is complete. Another procedure can be written below this line by starting again with 'to . . .'

How to access **Help** in your LOGO program

Procedures are written using the 'primitives' or the basic vocabulary that is recognised by the software. All the vocabulary can be accessed through the **Help** menu by selecting **Vocabulary...**

Clicking **Display** will give an explanation of the way that the word must be used, including precise syntax and also some examples of possible use. The use of the **Help** menu, far from being a sign of weakness, is central to children's development in this project. The feedback that the software gives through error messages, or seemingly obstinate insolence on the part of the turtle to obey commands, puts the children in the situation where they need to use analytical strategies to achieve their ends.

Help Topics: MicroWorlds Vocabulary

Contents | Index | Find

1 Type the first few letters of the word you're looking for.

setsh

2 Click the index entry you want, and then click Display.

setpos
setsh
setshape
setsize
setstyle
settc
setx
sety
shape
show
showtext
sin
size
snaparea
snapshape
snapshot
sol

Display | Print... | Cancel

MicroWorlds Vocabulary

File Edit Bookmark Options Help

Contents | Index | Back | Print | << | >>

setshape

setshape (setsh) *name-or-number*

setshape (setsh) *list-of-names-or-numbers*

Gives a shape to the turtle. If the input is a name, a quotation mark must precede it. The maximum number for **setshape** is 64. When a list of shape names or numbers is given as input, each **fd** and **bk** command makes the turtle cycle through the list of shapes (the maximum number of items in the list is 64). The shape can also be set by picking a shape from the Shapes Center and clicking on a turtle. See **shape** and *Animation Techniques* in *MicroWorlds Help Topics*.

Examples:

setshape 12

setshape "moon

repeat 25 [setsh "bird1 fd 2 setsh "bird2 fd 2]

setsh [dog1 dog2]

repeat 10 [fd 5]

glide 100 5

How to add and program buttons

Once procedures have been defined it is possible to call them up by typing the word that you have defined in the command window or by creating buttons to be clicked on a *MicroWorlds* project page.

The fifth icon down is the button tool. Selecting it and clicking on the page will open the button dialogue box.

As the procedure is already defined all I need to do is type the word 'shoal' into the instruction line. The instruction also becomes the button label. Thinking carefully about what you will call your procedures makes sure that the name appearing on the button makes sense. Selecting **Many Times** means that the procedure will be repeated until the button is clicked a second time.

How to support and challenge children to solve problems

This is the big challenge for all of us! Much has been written on creativity and the importance of open questions. We need to feel confident enough in our own knowledge of the software to encourage children to explore and evaluate their actions and not simply to tell them the answer – there rarely is only one! Similarly, a well-timed 'I wonder if . . .' can spur children on to set themselves new challenges, for their own problems are the ones that they are most motivated to resolve. Using the **Help** facility collaboratively can be a valuable experience, encouraging the children to move beyond the initial primitives that began the project. At the heart of your approach to supporting children in this project will be your philosophy of education. LOGO software was created by Seymour Papert as a response to the constructivist ideas of Piaget so it is hardly surprising that it may make you question your approaches – you have been warned!

What will the children learn?

How to create and control multiple turtle shapes

Working with multiple turtles brings new opportunities into LOGO work as well as the additional discipline of identifying which turtle(s) a procedure is targeting.

That ICT can be used to develop images

Children should have had several opportunities to create digital images already. The focus should be on the development of an image with animation in this instance. Encourage the children to use the computer as a planning tool – trying things out and exploring alternatives rather than reproducing an existing idea.

That ICT makes it easy to explore alternatives

The heart of the learning in this project is based on the provisional nature of ICT procedures and the ability to change a small command or variable and bring about great changes. By encouraging the children to test out alternative ideas their understanding of the value of ICT will increase.

To write repeating procedures to produce a desired outcome

Whether using the **Many Times** option discussed above or using repeat commands in their procedures, the children recognise the ability of the computer to carry out repetitive commands faithfully over long periods of time.

That procedures can call other procedures

It is important that the children see themselves as teaching the computer new commands when writing procedures. One good way to do this is through using the procedures that they have already defined, in other procedures. For example, if you encourage the children to create one super-procedure which will call up the other procedures in turn, then all the animations that they have programmed can take place by issuing one command or clicking one button.

Challenging the more able and supporting the less able: modifying the project for older and younger pupils

There is almost no end to the level of challenge that you can stimulate in a project of this sort – either through introducing the children to new primitive vocabulary and how they could use it, or through setting additional challenges. In the picture at the start of this project, for example, you could set the challenge of making the ship appear to sail closer and closer or you could teach a group the 'setsize' command. Once motivated, children will set their own demands as they try to achieve the effects that they require.

It is also possible to introduce conditional statements to stretch more able children who may wish things to happen when particular conditions are met – turtles meeting or leaving a path or track, for example.

For those who may struggle with the programming demands of the project we can prepare some basic procedures – a jumping movement, for example. The children are then able to use these procedures in a variety of contexts to create their own animation. It is also possible to import images or backgrounds, for children who may otherwise spend too long on the creation of the scene, so that they can focus on the animation. **Import** in the **File** menu enables pictures to be selected from a local disk and used as background or as turtle shapes.

The use of drama and off-screen drawing to help to sequence instructions can be a valuable aid to some children who are finding it difficult to get started. The sooner they begin to create procedures, however, the sooner they will benefit from

the feedback provided by the program. Problems with the sequencing of commands become evident from the behaviour of the turtle. Nevertheless, using role play where the child becomes the turtle and reading the instructions to them will often help children who are having difficulty debugging their procedures.

Why teach this?

The project teaches ICT NC KS2 PoS statements 2a–c and 3a and 3b and also gives an excellent opportunity to explore ICT tools described in 'Breadth of study' requirement 5b. Whether or not the work is focused around a theme, the task should have plenty of opportunity for the children to contribute ideas which will be developed as the animation scene evolves. The testing and refining of instructions described in 2b will be necessary for all the children. Most should also create their own procedures and some will include monitoring statements which respond to events in their animation. The sharing of their animation scenes and a consideration of the audience will need to be addressed as the projects are displayed; issues relating to how the buttons can be designed to communicate to the audience, so that they know what to do to make the animation work, make valuable learning opportunities. Section 4 of the PoS, 'Reviewing, modifying and evaluating work as it progresses', is central to this type of creative problem-solving activity. A 'work in progress' sharing of problems that they are trying to overcome can help to structure peer review to help with the development of the projects. The project provides opportunities to assess key skills at Level 3 (use sequences of instructions), Level 4 (make predictions) and Level 5 (explore the effects of changing variables).

The project complements and extends the Roamer and Turtle units (2D and 4E) in the QCA ICT Scheme of Work. It offers a creative context for developing similar outcomes as Units 5E: *Controlling devices* and 6C: *Control and monitoring – What happens when . . .?* and may motivate some children who would otherwise struggle with this part of the ICT curriculum.

This animation project can be approached through an Art & Design context, developing the children's creativity and imagination with the increasing complexity demanded of upper Key Stage 2. The roles of designers in the creation of animated digital media for games and television can also be studied as part of the knowledge and understanding required in statement 4c. It provides a good opportunity to explore accessible digital media and address the ICT use outlined in Art & Design 'Breadth of study' requirement 5c. The collection and exploration of visual elements to their designs, coupled with opportunities to evaluate the impact of their choices, will provide assessment information for Level 3 (make images for different purposes and adapt and improve), Level 4 (combining visual qualities to suit their intentions) and Level 5 (matching visual qualities to their intentions and adapt and refine to reflect their view of its purpose and meaning).

This project could contribute to the digital media strand of QCA Art & Design Scheme of Work Units 2A: *Picture this!* and 4A: *View points*. It would offer an interesting adaptation to Unit 6A: *People in action*.

By using LOGO in a creative design context children often set themselves far more demanding challenges than arise through teacher-initiated activities. As projects develop, children are far more motivated to solve problems that are of their own making than those which are externally contrived.

See *Learning ICT in Maths* Project 1 (*Using programmable toys*), *Maths* Project 4 (*Exploring with directions*) and *Maths* Project 7 (*LOGO challenges*) for related activities.

Project Fact Card: Project 9: Controlling external devices

Who is it for?

- 9- to 11-year-olds (NC Levels 3–5)

What will the children do?

Design and make model aliens with electrical circuits which operate lights, buzzers and motors. They will connect the circuits to the computer via a control interface and then plan and write control procedures to operate their alien.

What should the children know already?

- How to use sequences of instructions to control devices
- The importance of syntax and precision of language when writing instructions
- That instructions can be repeated
- That procedures can call other procedures

What do I need to know?

- How to connect an interface to the computer
- How to test that the interface is working properly
- How to write and run procedures
- How to use the feedback statements and **Help** facility in the control program
- How to support children's problem solving
- Simple circuitry including ensuring that output devices (bulbs, motors, etc.) match the voltage of the interface

What resources will I need?

- Control software and interface
- Bulbs, buzzers, motors and wire

What will the children learn?

- That machines and devices are controlled and that control devices must be programmed
- That sequence affects outcome
- That instructions can be recorded for replication and amendment
- That recording a sequence of instructions forms the basis of control work
- To write repeating procedures to produce a desired outcome

How to challenge the more able

- Increase the number and complexity of electrical circuits that they include in their model
- Set more complex challenges for the sequence of their control procedures
- Include sensors or input switches to monitor their models (necessary for Level 5)
- Set challenges which include *If* or *Wait until* statements in their procedures
- Introduce them to *feedback*

How to support the less able

- Manage the complexity of their models by including a smaller number of simple circuits
- Label outputs on the interface so that names can be used to simplify procedure writing
- Define some simple procedures that they can edit and use

Why teach this?

- Teaching ICT NC KS2 PoS statement 2b – creating, testing, improving and refining sequences of instructions – is at the heart of this project. The 'Reviewing, modifying and evaluating work as it progresses' strand of the ICT PoS is also developed through this type of procedure design and improvement activity. There is ample opportunity to investigate and compare the children's control work with ICT use in the home and society more widely as described in 'Breadth of study' requirement 5c.
- The project fills a gap in the progression of the QCA ICT units. Between 2D and 5E there are no units which provide an appropriate challenge to control events external to the computer.
- The project makes appropriate use of an ICT control program as described in statement 4c and electrical components in 5c of the D&T National Curriculum. It also makes a useful bridge between Units 4D and 4E and Units 6C and 6D of the QCA Scheme of Work, as well as providing good opportunities for evaluating processes and products described in section 3 of the D&T PoS.

Controlling external devices

What will the children do?

Control involves using the computer as an intelligent switch which means that virtually any model that includes electrical components can be controlled by computer. This project includes elements of D&T and ICT. The children will design and make model aliens with electrical circuits which operate lights, buzzers and motors. They will then connect their circuits to the computer via a control interface and plan and write control procedures to operate their alien.

Models or Mimics?

Software like Flowol (Flowol) and CoCo2 (Matrix Multimedia) have on-screen mimics which will respond to commands and procedures created in the software. While they are useful to demonstrate or test procedures they should only form part of the children's experience. Many children are already quite familiar with sophisticated on-screen models that they are able to control via their games hand-set and several new and important dimensions to their learning are opened up by controlling external models or devices. The facility of computers to control external switches is key to the understanding of all those domestic devices and manufacturing processes which work automatically. Precisely because the computer controlling tangible 3D models is less familiar to the children, the levels of motivation and challenge that they derive from the experience can be huge. It is particularly so when children work on their own models endeavouring to sequence events according to their own plan. When excited by the project children create their own problems which they are determined to solve.

This type of design project needs to balance the amount of time spent practically designing and making with time spent creating procedures and controlling the model. The two types of activity complement each other well as evaluation is at the heart of both processes. It is helpful to spend some time with the control software at the outset so that the children understand the potential and the limitations of the technology while they are designing their model. The introduction then needs to include a demonstration of a model. While many of the suppliers offer ready-made demonstration models for sale, if this is the first time that you have taught this type of D&T unit, making your own demonstration model will be valuable preparation.

Once the children have a grasp of the software, the ICT activities described below can proceed alongside the designing and making of their models using mimics or just bulbs and motors attached to the interface until their models are ready.

Activity 1: Under control

Task	Challenge
In the **Command** toolbar: Select **Turn output** Select **Turn: Output 1 on** Click **Run now** and check the interface In the **Command** toolbar: Select **Turn output** Select **Turn: Output 1 off** Click **Run now** and check the interface In the **Command** toolbar: Select **Say** Type ITS NOT MY FAULT Click **Run now** and listen	**Can you turn on more than one output at a time?**

Introduce the children to the software using an existing model. Initially the model can be controlled directly by clicking on the output represented on the screen. The computer will control the interface switching on and off the output circuits as instructed and any circuits connected to the interface will therefore be turned on. Next the children need to begin to use the control language. Most control software behaves in a similar way to Turtle LOGO but uses switching commands instead of directions. The instruction SWITCH ON 1 will turn on Output 1, for example. Different software uses different **primitives** (that is, the words which the software understands). Some will understand SWITCH or TURN but they all need the language and syntax to be used precisely. One way to develop the children's vocabulary of the primitives is to give them a list of instructions to try and see what happens.

The CoCo2 *screen*

Activity 2: Control Stories

Once the children have developed an idea of what the software can do they can begin to work on a *Control Story*. The story should outline in English the sequence of events that they want to happen when they connect their model alien to the interface. Clarifying the order and conditions that need to be met in their story makes the writing of their control **procedures** (a list of commands to be carried out by the computer) much easier.

Activity 3: Inputs and sensors

Making connections with any LOGO procedure writing which they may have done before, the children will now need to develop procedures to carry out the events described in their control story. How to create, run and modify a procedure will need to be demonstrated. One way is to provide the children with example procedures to modify (see first box on page 97):

If this activity is being used to provide NC Level 4 assessment opportunities in both controlling and sensing, the children will need to be taught how the inputs or sensors work and develop their control story to include a condition being met. For example, 'When you turn the alien upside down. . . Or if you press . . . then something will light up or be switched on'. The primitives associated with sensing or monitoring will also need to be taught. A sensor may be used as follows (see second box on page 97):

Task	Challenge
In the Program menu: Select **New procedure. . .** and name it STAR Check the new window title – Procedure: STAR Using the **Command** toolbar select the following commands (this time click 'Add' and position them in the procedure window): TURN OUTPUT 1 AND 3 ON WAIT FOR 2 seconds TURN OUTPUT 1 AND 3 OFF TURN OUTPUT 2 AND 4 ON WAIT FOR 2 seconds TURN OUTPUT 2 AND 4 OFF Click the play button ▣ at the bottom of the **Procedure: STAR** window and check the interface	**Can you double click on the 'Wait for. . .' command to alter the interval in your procedure called STAR?** **Try clicking on the step button ▣ to go through your procedure one command at a time.**

Task	Challenge
Connect a sensor to the interface and from the **View** menu select **Control Box > Sensors** Watch the range of readings change as you alter the environment of the sensor Create a new procedure called MONITOR Add: IF SENSOR 1 > 1 THEN:- SAY 'ITS HOT' End if Click the play button ▣ at the bottom of the **Procedure** window and check If the statement was true at the time the procedure ran, it will say 'It's Hot'; if not, it will do nothing	**Can you use REPEAT FOREVER to keep checking the sensor?**

Activity 4: Developing procedures

The final activity needs to allow enough time for the children to develop and modify their procedures to realise their control stories with their model aliens. Decisions to extend or restrict the Control Stories to maintain an appropriate challenge will need to be made. Some programming can be undertaken using mimics if control interfaces are in short supply.

What should the children know already?

How to use sequences of instructions to control devices

This project is not impossible for children new to any type of control software but the extent to which they are able to develop more complex procedures may be restricted. As it is likely that the control software will be different from anything that they have used before, it is important to draw comparisons with their use of programmable toys like Roamer and any previous use of LOGO.

The importance of syntax and precision of language when writing instructions

Remind the children how they have used sequences of instructions to control toys or screen turtles and what happened if the commands were not written precisely using the right language and syntax.

That instructions can be repeated

Some children will have used the REPEAT command to produce regular shapes using Turtle LOGO and many LOGO commands will apply equally well in most control software.

That procedures can call other procedures

The project aims to develop the understanding that sets of commands called procedures, which they have created to draw shapes on the screen, can similarly be created to make lights flash or motors turn. Reminding the children that procedures can call other procedures will also accelerate their use of control software.

What do I need to know?

How to connect an interface to the computer

It is important to realise that the computer is not providing the energy for the components attached to the interface. It is merely controlling which interfaces outputs are switched on when and for how long, while also monitoring the inputs and any connected sensors. Any interface, therefore, needs to be connected to the mains for its power supply and to the computer to send and receive information. Interfaces will either have a serial or USB lead to connect to the computer. Connect the interface to the socket on your computer specified by the manufacturer and to the power supply and then switch on the interface before you start up the computer. With new computers and control boxes the order is less important but some older systems need to be able to recognise that the interface is connected for the software to load properly.

How to test that the interface is working properly

With the interface connected and switched on, run the software from the **Start** menu or desktop icon. Software will often give a message on start-up that it detects the interface but the easiest way to check is to click on one of the outputs on the screen and see whether the corresponding output on the interface lights up. If it does not appear to be working, check that the interface is switched on and then check the menus in the software. You may be able to connect to the interface or check the interface using the software. It is also worth checking whether the software allows you to specify the type of interface as there are several on the market. Normally the software and interface would have been purchased together, however, so compatibility should not be an issue.

How to write and run procedures

The precise system for writing procedures varies from software to software but you should expect to be able to directly enter and run a command and to be able to create a new procedure – that is, define what will happen each time a particular word is used. Procedure names can be anything apart from primitives (words which the software already knows – Remember?) –

e.g.
To STAR
TURN OUTPUT 1 AND 3 ON
WAIT FOR 2 seconds
TURN OUTPUT 1 AND 3 OFF
TURN OUTPUT 2 AND 4 ON
WAIT FOR 2 seconds
TURN OUTPUT 2 AND 4 OFF
End

Some software has a **New Procedure** option which you select and name before a new window appears for you to write the procedure in. In that case the 'To STAR' line is not needed, nor is the 'End'. Once defined, each time the procedure is run or any time the word STAR is encountered in another procedure this list of instructions will be carried out. It is rather like teaching the computer a new word.

How to use the feedback statements and **Help** facility in the control program

A fundamental part of writing control procedures is the approach to problem solving which it engenders. Central to the learning process is the feedback which the software gives and the way that the children seek to respond. Feedback can be in the form of an error message or can, indeed, be the way that the model responds. The idea is that by an iterative process the children come closer and closer to the intentions expressed in their Control story. Error messages may suggest what is needed in a procedure and by consulting the **Help** menu children can see examples of how to use the commands. The **Help**

menu, far from being an admission of defeat, is an important stage in the procedure writing process. Helping children to break down their story into discrete events which can become procedures and suggesting commands to try, so that the problems remain in the possession of the children, is a key ingredient of teaching and learning in this project.

How to support children's problem solving

Some see a response which does not contain a definitive answer as a sign of weakness in a teacher. On the contrary, it is the teacher that knows not one but several answers who is able to guide children to a solution of their own. The central purpose of the exercise must be the learning and the development of the children's capability, not the smooth functioning of the model. Within the constraints of time try to encourage experimentation. Be alert to the need to teach the children new commands. Encourage complex events to be broken down and written and tested as smaller procedures.

Simple circuitry including ensuring that output devices (bulbs, motors, etc.) match the voltage of the interface

Computer-controlled models actually have simpler circuitry than models with batteries and switches as the computer takes over the task of controlling the supply of energy. Each output device – lamp, motor or buzzer – that needs to be switched independently must have its own circuit and be connected to a separate output on the interface. Input circuits can have any switch connected to them as the computer is able to detect when a circuit is made across the terminals of any input.

When creating models in a project like this one the children need to be given components that match the output voltage of the interface. The output voltage of the interface should be clearly marked on the casing. Most are 5 or 6 volts but some can be switched to either 6 volts or 12 volts – beware! 6 volt bulbs, buzzers and motors are readily available. Many buzzers are polarity sensitive – that is, they must be wired the right way round. They usually come with one red and one black wire; observe the convention and make sure the red wire is attached to the positive terminal.

What will the children learn?

That machines and devices are controlled and that control devices must be programmed

To understand the connection between their own model and other machines with which they are familiar, the concept of Control Stories can be extended to describe other automatic events – e.g. automatic doors.

That sequence affects outcome

There will usually be sequencing issues which arise with any task of this sort. Short class activities fixing problems with malfunctioning procedures can be useful.

Most software will enable the dragging and dropping of lines of procedures to reorder them.

That instructions can be recorded for replication and amendment

The power of defining and recalling procedures will become evident as the children develop the control of their alien. As the children are encouraged to use super-procedures (which call up other procedures that they have already defined) calling up one procedure can lead to a complex series of events.

That recording a sequence of instructions forms the basis of control work

From the start of their Control Story to the precision of each procedure that they write, the importance of accurate instructions, properly sequenced, needs to be stressed. The mechanical way in which the software executes instructions precisely reinforces the need for clarity when thinking through the order of events.

To write repeating procedures to produce a desired outcome

The opportunity for children to define their own outcomes provides a powerful motivational driving force to this project. Their desire to achieve the outcome can plumb hidden depths of perseverance within some children.

Challenging the more able and supporting the less able: modifying the project for older and younger pupils

By increasing the number and complexity of electrical circuits that are in a model both the construction and the subsequent programming of their control procedures can be made more challenging. Some use of parallel circuitry for lamps that are going to be lit together or inputs which include AND and OR logic, for example, can be introduced. For two conditions to be met – e.g. if you squeeze the alien's finger while he is lying down – either two switches could be wired in series to one input or two separate inputs could be monitored simultaneously by a procedure.

Either solution makes the task more complex. Including sensors to monitor their models (necessary for Level 5) brings in the need to use inequalities in the procedures – e.g. IF SENSOR 3 > 34 or WAIT UNTIL SENSOR 2 < 10. Introducing the concept of *feedback,* where systems are maintained in balance by constant monitoring, can be achieved in LOGO systems by recursion (where a procedure calls itself up and so continues checking a condition or series of conditions forever), or in software that does not support that approach a REPEAT FOREVER loop or WHENEVER command is usually available.

A degree of success and useful learning can be achieved with simple models including a smaller number of simple circuits to support less able children. Most primary control software also allows the outputs to be labelled. For example, if the name of Output 2 is changed to NOSE then writing the line SWITCH ON NOSE

in a procedure would turn on Output 2. The result is that the procedures are much more easily understood. If the creation of original procedures is too challenging for some children, then defining simple procedures that they can edit and use can help.

Why teach this?

The project seeks to provide a context to teach ICT NC KS2 PoS statement 2b – creating, testing, improving and refining sequences of instructions. It is an aspect of the curriculum that is sometimes missed and one which will not be addressed incidentally without a conscious plan. The recognition that computers control physical events is an important element of the development of ICT capability. The 'Reviewing, modifying and evaluating work as it progresses' strand of the ICT PoS is also developed through this type of procedure design and improvement activity. There is ample opportunity to investigate and compare the children's control work with ICT use in the home and society more widely as described in 'Breadth of study' requirement 5c. It is important to recognise that the connections to control in society will not happen automatically and careful planning is also needed to forge those links.

The project fills a gap in the progression of the QCA ICT units. Between 2D and 5E there are no units which provide an appropriate challenge to control events external to the computer.

The project makes appropriate use of an ICT control program as described in statement 4c and electrical components in 5c of the D&T National Curriculum. It also makes a useful bridge between QCA Scheme of Work Units 4D: *Alarms*, 4E: *Lighting it up*, 6C: *Fairground* and 6D: *Controllable vehicles* as well as providing good opportunities for evaluating processes and products described in section 3 of the D&T PoS.

See *Learning ICT in Maths* Project 1 (*Using programmable toys*), *Maths* Project 4 (*Exploring with directions*) and *Maths* Project 7 (LOGO challenges) for related activities.

Project Fact Card: Project 10: Creating a digital 'silent film'

Who is it for?

- 9- to 11-year-olds (NC Levels 3–5)

What will the children do?

Using silent films as a starting point the children will use digital video cameras to record scenes that they have planned by creating a storyboard. The clips are downloaded to the computer and edited using software. Using digital effects and titles a short film is created. A musical accompaniment is composed and recorded or performed live to respond to the action and moods of the film.

What should the children know already?

- That pictures can be stored in digital cameras and transferred to the computer for editing
- That screen objects can be dragged to reposition them

What do I need to know?

- How to connect a digital video camera to the computer
- How to download video clips from the camera
- How to use the video-editing software to sequence the clips
- How to trim unwanted frames from a video clip
- How to add text to the film
- How to add transitions between scenes
- That video files take up large amounts of memory

What resources will I need?

- Digital video cameras
- Video-editing software – Digital Blue *Movie Creator* or *Windows Movie Maker*

What will the children learn?

- To organise, refine and present information in different forms for a specific audience
- To select suitable information and media and prepare it for processing using ICT
- That ICT can be used to develop images and that a screen image can be a finished product
- That pictures and sounds can be combined in a performance
- That ICT makes it easy to arrange and reorder video clips and explore alternatives

How to challenge the more able

- There are many facets to this project and able children can be challenged through the drama, the camera techniques, the complexity of their storyboards, the attention to detail and application of effects to the film, the composition and performance of the music or through subsequent artwork arising from stills taken from the film

How to support the less able

- The collaborative nature of this project provides a valuable opportunity for working together. Balancing the teams at the outset can provide valuable peer support. Providing adult support for elements that individuals find challenging will help. The integrated nature of the project should enable each child to have opportunities to contribute and to learn

Why teach this?

- This project brings an exciting dimension to section 3 of the ICT NC KS2 PoS, 'Exchanging and sharing information'. The process of editing addresses statements 2a and 2c as they organise and reorganise their video clips appropriately and evaluate the effect. It also gives an excellent opportunity to discuss the strengths and weaknesses of the use of ICT as required by the 'Reviewing, modifying and evaluating work as it progresses' strand of the ICT PoS.
- The project builds on the manipulation of text, graphics and sound covered in Units 3A and 3B of the QCA ICT Scheme of Work. The ability to model and evaluate alternatives developed in Unit 4E is a valuable part of the project. It offers an alternative to Unit 6A if the children are encouraged to create storyboards as part of the planning process.
- The project provides opportunities to incorporate the composing and performing skills described in the KS2 Music NC. Many of the intentions of QCA Music Units 9, 16, 20, and 21 can be achieved through this project. Within Art & Design the work of film-makers can be explored and the film can be an example of digital media or be a starting point for other practical work.

Creating a digital 'silent film'

What will the children do?

A good start for this project would be to watch and evaluate a silent film together. As the music is one of the key creative components, listening to the soundtrack alone and trying to interpret the action on a simple storyboard would set the scene. The activities are best carried out in mixed ability groups with opportunities for collaborative planning. The film needs to tell a short story that can be developed through drama before being planned and recorded as a series of sketches with explanations on a storyboard. The plan is important to help with evaluation and assessment of the group's intentions. It is also worth demonstrating what can be done with the video-editing software at this stage so that the children are able to make realistic plans.

Activity 1: Storyboards

The storyboard activity has ICT opportunities although it can be completed without any computer use. The children could use a word processor or publishing software to construct their storyboard.

1. Title page	2. :) :)	3. 'I haven't seen you for ages'	4. :) :) :(
	Two children meet in the corridor and begin to talk	Caption page	While they talk a person that they can't see listens to them talking
5.	6.	7.	8.

Storyboard table

The scene that the children plan to shoot can be drawn or described in each box. An additional ICT dimension can be included by using a digital camera to take pictures of the intended location for each scene. The pictures can then be inserted into the table to illustrate the storyboard.

Activity 2: On location

Once the children have a plan then filming can begin. Either through demonstration, using the camera and projecting the live image onto the whiteboard, or through analysing videos, the impact of some of the conventions of film should be discussed. Terms like 'long-shot', 'close-up' and 'pan' may already be familiar to the 10- or 11- year-olds. Considering the impact of their choice of camera position, for example filming someone from a very low angle or from above, can also be evaluated. When the children are familiar with the cameras then they will need to be taught how to download the film clips to the computer so that they can empty the camera's memory to make room for more clips.

Activity 3: The cutting room

With the film clips of all the scenes of the story saved on the computer, the children can begin to edit their films. Clips need to be assembled in the required order and then caption pages can be created and inserted. The ability to order and reorder film clips with digital video is one of its major advantages over linear video tape editing. Children will need to be taught how to trim unwanted frames from their film clips and then decide on the type of transition that they want between scenes and captions.

The final part to this project is the composition and addition of the music to accompany the children's films. The stories of cinema organists and pianists who would add improvised music to the action that they were watching on the screen are interesting to explore, if time allows. It is worth bringing the children back to their storyboards to describe a mood or type of music that needs to accompany each scene and then discuss appropriate instruments. While the soundtrack could be recorded and added to the film, it is arguably of greater benefit to the development of musical performance skills for the music to be performed live while the film is played back.

What should the children know already?

That pictures can be stored in digital cameras and transferred to the computer for editing

Although this may be the first experience of digital video editing that the children have, most will be aware that pictures can be stored in digital cameras and transferred to the computer for editing. The idea that images need to be saved in some form of memory in the camera and that, once the information has been transferred

to the computer, the camera's memory can be cleared to save new images is revisited and reinforced in this project.

That screen objects can be dragged to reposition them

Previous work in positioning pictures in **documents** and editing will help the children to recognise the provisional nature of their film and how errors can be corrected and improvements made at any stage in the process.

Most digital video-editing software is very visual, with the film clips, effects and transitions represented as icons on the screen which can be selected and positioned as desired. A prior understanding that screen objects can be **dragged** to reposition them will help the children to become proficient in the skills of digital video editing.

What do I need to know?

Several pieces of software are available for digital video editing. Apple's *iMovie* software led the way with an interface that was understood by young children and fast transfer of video from digital cameras. The Digital Blue software described in this project is accessible to Key Stage 1 children with suitable support and comes as a package with a basic video camera and software at affordable cost. Its main advantage is that the transferring and saving of files is managed in a very simple way. Windows XP also has *Windows Movie Maker* (see Project 6) which could be used for this project but would need careful management of video files.

How to connect a digital video camera to the computer

The key development that makes this type of project accessible to primary children is the availability of low-cost digital video cameras. For video to be edited on a computer the images need to be in digital format so it is important that any camera that you use is a digital video (DV) camera. The instructions and cable needed to connect the camera to the computer would normally be supplied with the camera and the majority plug into the USB port on the computer. Usually it is necessary to install any software before connecting the camera to the computer for the first time. The camera instructions supplied by the manufacturer should make this clear.

How to download video clips from the camera

Most video-editing software will have at least two modes of operating – a live or 'connect to camera' setting and an editing mode. In addition, the Digital Blue software has a third 'exchanging and sharing' mode, where finished films can be viewed. In the 'live' mode, the software recognises when a camera with images in its memory is connected by displaying a dialogue box which identifies the number of items – movie

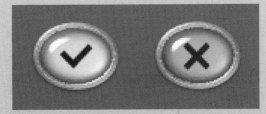

clips – and asks whether you want to download them. If you select the tick, the clips are transferred to a temporary clipboard for viewing. There is no playback facility in the low-cost cameras supplied with the software so until the clips are on the computer the skill of the camera operator cannot be evaluated. The temporary clipboard is cleared when the software is closed. To keep clips for use later they must be transferred to the permanent clip collection either one at a time ('Transfer to permanent: One') or all at once ('Transfer to permanent: All').

How to use the video-editing software to sequence the clips

In the editing mode clips can be assembled in the required order by dragging them from the permanent clipboard onto the storyboard. Some background screens are provided with the software and it is possible to import still images from other applications to be used as backgrounds for the caption screens.

How to trim unwanted frames from a video clip

If a clip has unwanted frames in it, it is possible to remove them by using the trim tool. When filming, a clip is recorded by keeping the recording button on the camera depressed. Each time it is released and pressed in again a new clip is created. To use just part of a clip select it in the storyboard and then click on the trim button.

The clip will appear in a new window where it can be reviewed frame by frame. The red triangles at either end of the green bar can then be dragged to indicate the new start and end of the clip. The play button allows you to review the effects of your trimming before you select the tick to accept your changes or the cross to reject them. You can even remove a section from the middle of a clip by inserting it onto the storyboard

twice and trimming the middle and end from the first and the beginning and middle from the second. When you play the film the two clips will run together.

How to add text to the film

When the action is running in the desired sequence, caption frames can be inserted where needed and text added. The three buttons down the left-hand side of the editing screen provide access to text, special and sound effects. First of all insert the caption screen background where it is needed on the storyboard and select it. Make sure that the clipboard is up so that the editing screen is visible. Then select the top button on the right-hand side of the screen so that the text tools are revealed.

This set of tools enables paint and filters to be applied over the film

as well as text. To add a text box select the 'a' tool and click the '+' button at the bottom of the tools panel. Text can then be typed using the computer keyboard. Text boxes appear with a border around them while the text tools are being used; the border is not visible when the film is played. A selected text box has a thick green border to indicate that it is the currently active box. While the green border is surrounding a text box any options selected from the tools are immediately applied so that the impact of the choices can be evaluated. The top of the display indicates the colour palette and active text colour. The arrow keys under the palette allow other palettes to be selected. The

size of the font is chosen by clicking and dragging the slider between A and A. There are only three fonts which can be selected by clicking on the appropriate **Aa** button and the text can be centred or justified to the right or the left. The bottom section of the tool panel makes it possible to opt for the text to scroll, like the credits at the end of a film, and to set a scroll speed.

The text box can be resized by clicking and dragging on the small box by the bottom right-hand corner, or moved by dragging the border.

How to add transitions between scenes

Anyone who watches films or television will be familiar with transitions between scenes. One of their functions is to maintain continuity so we are often unaware of the effect – until we begin to look out for them. By using a wipe effect, for example, we can make the caption board appear to be slid to one side to reveal the next scene. The transition effects are accessed by clicking on one of the small squares between clips on the storyboard. The transitions tab will then appear and an effect can be chosen. Most effects are recognisable from the icon but holding the mouse over the icon without clicking (hovering) will reveal the name of the effect and selecting one will enable you to preview the transition in your film. An effect can be changed by clicking on the small transition box between the relevant clips on the storyboard once more and choosing a different one.

That video files take up large amounts of memory

Video files take up large amounts of memory! Why? Well pictures need large amounts of information to be stored in order to detail the appearance of each dot on the screen. Full motion video requires 25 images a second! Digital Blue creates a lower quality video with 15 frames a second and manages the saving of files within the software well. So long as there is plenty of hard disk space on the computer, there should be no problems. There is also the ability to export complete films which can be played back

using *Windows Media Player* (although some more recent versions of *Media Player* have difficulties with the specific Windows Video File (.avi) format of video which Digital Blue exports) or *QuickTime* (which is a free video player available from Apple). Short films are likely to be between 10 and 100 megabytes of data, so a USB drive could be used if the destination of the film is not on the same network as the computer which created it.

What will the children learn?

To organise, refine and present information in different forms for a specific audience

Developments in technology have made it increasingly possible to process visual information using computers. The ability to store large amounts of data has opened the door to video editing enabling children to be creators of films. This project enables the children to consider the impact of their editorial choices on the audience, as film producers do, when they refine and edit their films. The initial planning and organising present fruitful learning opportunities as well as developing collaborative discussion and negotiation.

To select suitable information and media and prepare it for processing using ICT

The type of choices that children make when filming and transferring their clips to the computer are different but no less challenging than a data collection and information-handling type of project that involves the processing of numeric data. It can provide an intellectually challenging problem for children who are not inspired by numbers and statistics and help them to understand the power and versatility of computers through the role that they play in the production of digital media.

That ICT can be used to develop images and that a screen image can be a finished product

This project should build on children's previous experience of manipulating images. Through placing moving images in a particular order children's understanding of the effects that can be achieved can be powerful learning which will have an impact on their development, both as creators and consumers of moving images. The dynamic effects that are created reinforce the idea that the finished product is best viewed on the screen.

That pictures and sounds can be combined in a performance

For the musical performance elements of this project to be fulfilled, the playing of the compositions live to respond to the timing and mood of the films is a key component of the learning. Even if the music is going to be recorded to be added to the

video file, it will need to be performed to coincide with the events on the film as it is recorded. Recordings can be used as potent aids to evaluation as the children consider the mood that they set out to create in their original plans.

That ICT makes it easy to arrange and reorder video clips and explore alternatives

Encouraging the children to try their ideas and evaluate the consequences is the most effective way for them to understand the potential of the technology. As the clips that they film remain stored in the software they can revert to their original film if they make changes that they do not like. Most effects applied during the editing stage can be undone, making the exploration of alternatives easy.

Challenging the more able and supporting the less able: modifying the project for older and younger pupils

All children can be challenged appropriately in one of the aspects of this project. For some children it may be through the drama, especially as in a silent film the emphasis will be on mime rather than learning lines or speaking. For others the emphasis may be on the camera techniques or the complexity of their storyboards. Encouraging children to imagine an effect that they want to create or to film different angles to help to communicate the intentions of the actors can be a good way to stretch able children. Aim to ensure that children communicate their ideas for their films so that they can be reminded of the detail when applying effects to the film or during the composition and performance of their music. You may wish to extend some children by exporting stills from the finished film to use as the starting point for artwork.

The collaborative nature of this project provides a valuable opportunity for working together. Balancing the teams at the outset can provide valuable peer support and ensure that the strengths of less able children are allowed to shine while the inclusion of more literate children in each group will provide support with caption writing. Providing adult support for elements that individuals find challenging can be useful, although other aids, like writing frames or word banks, can be employed to assist with the storyboard construction. The Digital Blue cameras are designed to be handheld, but simple techniques to support the cameras during filming can be taught or tripods acquired if the steadiness of hand required is an issue for some children. The integrated nature of the project means that, when planned using information about the learning needs of the individuals in the class, each child should have opportunities to contribute and learn.

Why teach this?

Although this type of video project might seem complex at first glance, the technology is certainly within the reach of most children at Key Stage 2. Children are

increasingly discerning consumers of information in this medium and recognise many of the conventions and techniques that are used. The opportunity to film and edit video material rarely fails to promote enthusiasm for learning and fun in any classroom.

The project brings an exciting dimension to section 3 of the ICT NC KS2 PoS, 'Exchanging and sharing information'. It will extend the various forms of ICT that children can use to communicate and provides opportunities to teach the children to think carefully about the content of their films and the needs of their audience. The process of editing the videos addresses statements 2a and 2c as they organise and reorganise their video clips appropriately and explore and evaluate the effect. It also gives an excellent opportunity to develop the 'Reviewing, modifying and evaluating work as it progresses' strand of the ICT PoS through discussing the strengths and weaknesses of the use of ICT for video editing.

The project builds on the manipulation of text graphics and sound covered in Units 3A: *Combining text and graphics* and 3B: *Manipulating sound* of the QCA ICT Scheme of Work. The ability to model and evaluate alternatives developed in Unit 4E: *Modelling effects on screen* is a valuable part of the project. Transitional effects and backgrounds can be applied and removed or adopted following discussion and evaluation by the group. By ensuring that the children create storyboards as part of the planning process, the project could be an alternative to Unit 6A: *Multimedia presentation* as the key ideas are the same.

The project provides opportunities to incorporate many of the composing and performing skills described in the KS2 Music NC. At the outset the composition can be developed through improvisation and the film provides a time-related structure for the compositions, enabling the combination and organisation of musical ideas. Many of the intentions of the following QCA Music units could be achieved through this project by adapting the context:

⊙ Unit 9: *Animal magic – Exploring descriptive sounds*

⊙ Unit 16: *Cyclic patterns – Exploring rhythm and pulse*

⊙ Unit 20: *Stars, hide your fires – Performing together*

⊙ Unit 21: *Who knows? – Exploring musical processes*

It is also possible to justify elements of this project within the Art & Design NC PoS. The work of film-makers can be explored and the techniques and tools available in the software tried and applied. Encouraging review and evaluation of the work in groups and as a class will help to develop the film as an example of digital artwork and contribute to the children's understanding of materials and processes to make images.

See *Learning ICT in English* Project 8 (*Digital video*), *Humanities* Project 9 (*A video of a visit to a place of worship*) and *Science* Project 8 (*Digital video – freeze frame*) for related activities.

Acknowledgement

All screenshots of Digital Movie Creator™ ©2002 in this project appear courtesy of Digital Blue™ and Prime Entertainment Inc. (www.playdigitalblue.com). All rights reserved.

Index

TEACHING ICT THROUGH THE PRIMARY CURRICULUM

David Fulton Publishers

Learning ICT in the Humanities

Tony Pickford

Primary

Providing practical guidance on enhancing learning through ICT in the humanities, this book is made up of a series of projects that supplement, augment and extend the QCA ICT scheme and provide much-needed links with Units in other subjects' schemes of work.

It includes:

- Examples and advice on enhancing learning through ICT in history, geography and RE

- Fact cards that support each project and clearly outline its benefits in relation to teaching and learning

- Examples of how activities work in "real" classrooms

- Links to research, inspection evidence and background reading to support each project

- Adaptable planning examples and practical ideas provided on an accompanying CD Rom

Suitable for all trainee and practising primary teachers.

£20 • Paperback • 112 pages • 1-84312-312-6 • June 2006

Learning ICT with English

Richard Bennett

Primary

Providing practical guidance on enhancing learning through ICT in English this book is made up of a series of projects that supplement, augment and extend the QCA ICT scheme and provide much-needed links with Units in other subjects' schemes of work.

It includes:

- Fact cards that support each project and clearly outline its benefits in relation to teaching and learning

- Examples of how activities work in "real" classrooms

- Links to research, inspection evidence and background reading to support each project

- Adaptable planning examples and practical ideas provided on an accompanying CD Rom

Suitable for all trainee and practising primary teachers.

£20 • Paperback • 148 pages • 1-84312-309-6 • May 2006

Learning ICT with Maths

Richard Bennett

Primary

Providing practical guidance on enhancing learning through ICT in maths, this book is made up of a series of projects that supplement, augment and extend the QCA ICT scheme and provide much-needed links with Units in other subjects' schemes of work.

It includes:

-Fact cards that support each project and clearly outline its benefits in relation to teaching and learning

- Examples of how activities work in "real" classrooms

-Links to research, inspection evidence and background reading to support each project

- Adaptable planning examples and practical ideas provided on an accompanying CD Rom

Suitable for all trainee and practising primary teachers.

£20 • Paperback • 144 pages • 1-84312-310-X • April 2006

Learning ICT with Science

Andrew Hamill

Primary

Providing practical guidance on enhancing learning through ICT in science, this book is made up of a series of projects that supplement, augment and extend the QCA ICT scheme and provide much-needed links with Units in other subjects' schemes of work.

It includes:

- Fact cards that support each project and clearly outline its benefits in relation to teaching and learning

- Examples of how activities work in "real" classrooms

- Links to research, inspection evidence and background reading to support each project

- Adaptable planning examples and practical ideas provided on an accompanying CD Rom

Suitable for all trainee and practising primary teachers.

£20.00 • Paperback • 128 pages • 1-84312-311-8 • April 2006

Ordering your books couldn't be easier! See next page for details.

Progression in Primary ICT

Richard Bennett, Andrew Hamill & Tony Pickford

Primary

Providing an overview of the current context of ICT teaching within the primary classroom and an analysis of how to progress with it in order to enhance learning, this text:

- Provides an analysis of what progression in ICT is and breaks this down into a series of detailed objectives
- Includes "real life" examples and case studies that highlight how progression occurs within the classroom
- Contains a reference chart that documents progression in terms of learning objectives and subject content
- Gives advice on teaching ICT in different settings or with varied resources

Suitable for all practising and trainee primary teachers.

£20 • Paperback • 160 pages • 1-84312-308-8 • Sept 2006

Order Form:

Qty	ISBN	Title	Price	Subtotal
	1-84312-312-6	Learning ICT in the Humanities	£20.00	
	1-84312-309-6	Learning ICT with English	£20.00	
	1-84312-310-X	Learning ICT with Maths	£20.00	
	1-84312-311-8	Learning ICT with Science	£20.00	
	1-84312-308-8	Progression in Primary ICT	£20.00	
		Free P&P to schools, LEAs and other organisations	P&P	
			TOTAL	

Reference Number: DFICTA

Name:_____

Organisation:_____

Address:_____

_____ Postcode:_____ Tel:_____

P&P £2.50 for all private orders. Prices and publication dates are subject to change.

To order

Send to: David Fulton Publishers, The Chiswick Centre, 414 Chiswick High Road, London W4 5TF.
Telephone: 0845 602 1937 Fax: 020 8742 8767

☐ *Please add me to your email mailing list. Email:_____*

Payment

☐ **Please invoice** *(applicable to schools, LEAs and other institutions)* ☐ *I enclose a cheque (payable to David Fulton Publishers Ltd.)*

☐ **Please charge to my card** *(Visa/Barclaycard/Access/MasterCard/American Express/Switch/Maestro/Delta)*

Card number: ☐☐☐☐ ☐☐☐☐ ☐☐☐☐ ☐☐☐☐ ☐☐☐☐

Valid from: ☐☐☐ Expires: ☐☐☐ Issue No (Switch only): ☐ Signature:_____